PAINT ALONG WITH JERRY YARNELL • VOLUME ONE

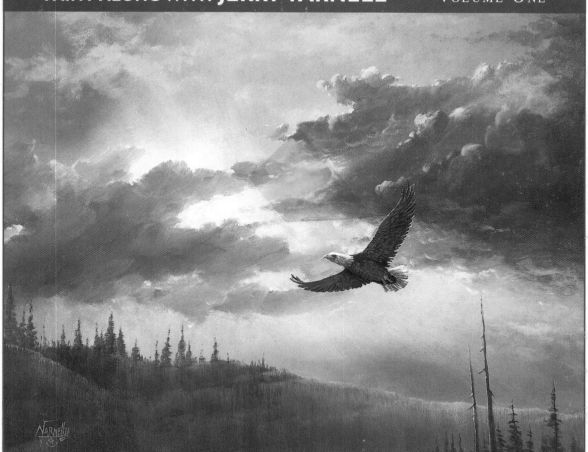

PAINTING
Basics

751.426
YAR
vol. 1

NORTH
LIGHT
BOOKS

CINCINNATI, OHIO
www.nlbooks.com

ABOUT THE AUTHOR Jerry Yarnell was born in Tulsa, Oklahoma, in 1953. A graduate of the Philbrook Art Center in Tulsa, Jerry has always had a great passion for nature and has made it a major thematic focus in his painting. He has been rewarded for his dedication with numerous awards, art shows and gallery exhibits across the country. His awards include the prestigious Easel Award from the Governor's Classic Western Art Show in Albuquerque, New Mexico, acceptance in the top 100 artists represented in the national Art for the Parks Competition, an exhibition at the Leigh Yawkey Woodson Museum Birds in Art Show

and participation in a premier showing of work by Oil Painters of America at the Prince Gallery in Chicago, Illinois.

Jerry has another unique talent that makes him stand out from the ordinary: He has an intense desire to share his painting ability with others. For years he has held successful painting workshops and seminars for hundreds of people. Jerry's love for teaching also keeps him very busy holding workshops and giving private lessons in his new Yarnell School of Fine Art. Jerry is the author of three books on painting instruction, and his unique style can be viewed on his popular PBS television series, *Jerry Yarnell School of Fine Art*, airing worldwide.

Paint Along With Jerry Yarnell, Volume 1: Painting Basics. © 2000 by Jerry Yarnell. Manufactured in China. All rights reserved. No part of this book may be reproduced in any form or by any electronic or mechanical means including information storage and retrieval systems without permission in writing from the publisher, except by a reviewer, who may quote brief passages in a review. Published by North Light Books, an imprint of F&W Publications, Inc., 1507 Dana Avenue, Cincinnati, Ohio 45207. (800) 289-0963. First edition.

Other fine North Light Books are available from your local bookstore or art supply store or direct from the publisher.

04 03 02 01 00 5 4 3 2 1

Library of Congress Cataloging-in-Publication Data

Yarnell, Jerry.
 Paint along with Jerry Yarnell.
 p. cm.
 Includes index.
 Contents: v. 1. Painting basics.
 ISBN 1-58180-036-3 (pbk. : alk. paper)
 1. Acrylic painting—Technique. 2. Landscape painting—Technique. I. Title

ND1535 .Y37 2000
751.4'26—dc21 00-033944
 CIP

Editor: Tricia Waddell
Designer: Angela Wilcox
Cover Designer: Brian Roeth
Production Coordinator: John Peavler
Production Artist: Lisa Holstein
Photographers: Christine Polomsky and Greg Albert

DEDICATION

It was not difficult to know to whom to dedicate this book. I give God all the praise and glory for my success. He blessed me with the gift of painting and the ability to share this gift with people around the world. He has blessed me with a new life after a very close brush with death. I am here today and able to share all of this with each of you because we have a kind, loving and gracious God. Thank you, God, for all you have done.

Also to my wonderful wife Joan, who has sacrificed and patiently endured the hardships of an artist's life. I know she must love me or she would not still be with me. I love you sweetheart and thank you. Lastly, to my two sons, Justin and Joshua: You both are a true joy in my life.

ACKNOWLEDGMENTS

So many people deserve recognition. First I want to thank the thousands of students and viewers of my television show for their faithful support over the years. Their numerous requests for instructional materials are really what instigated the process of producing these books. I want to acknowledge my wonderful staff, Diane, Scott, and my mother and father for their hard work and dedication. In addition, I want to recognize the North Light staff for their belief in my abilities.

FOR MORE INFORMATION

about the Yarnell Studio & School of Fine Art and to order books, instructional videos and painting supplies contact:

Yarnell Studio & School of Fine Art
P.O. Box 808
Skiatook, OK 74070

Phone: (877) 492-7635

Fax: (918) 396-2846

gallery@yarnellart.com

www.Yarnellart.com

Table of Contents

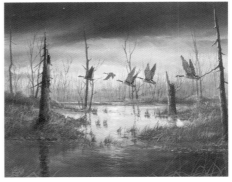

Evening Flight

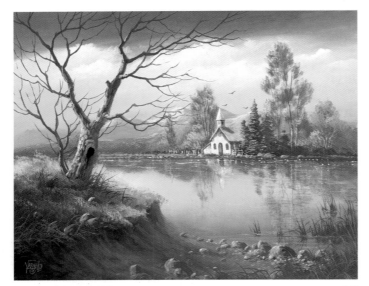

Church in the Wildwood

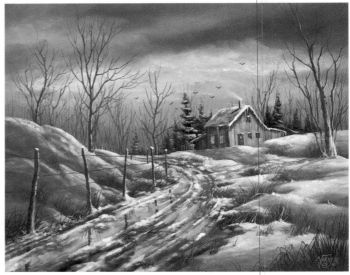

Winter Delight

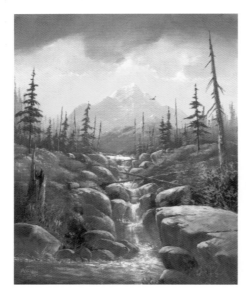

High Country Majesty

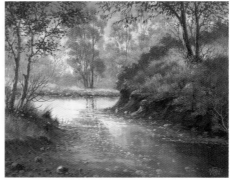

Autumn Memories

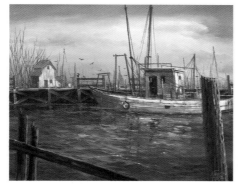

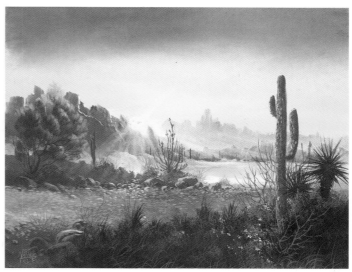

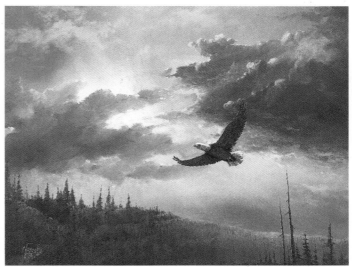

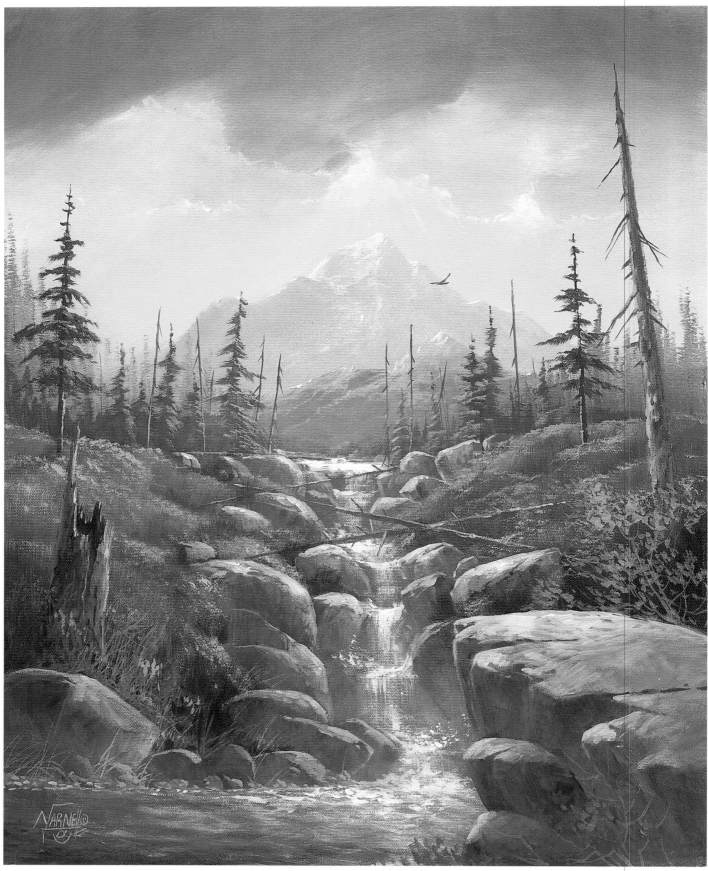

High Country Majesty
20" x 16" (50.8cm x 40.6cm)

Introduction

Welcome to the wonderful world of acrylic painting. I am Jerry Yarnell and I will be your guide on this truly exciting painting adventure. Many of you have been following my national PBS TV show, The Inspiration of Painting, for many years. I now have a new instructional show, The Yarnell School of Fine Art, which can be seen in most major cities across the country and in several foreign countries. This book is based on the information I teach on these shows, so it is a great companion and guide to the instructional videos that you may already have. In this book I try to reach the beginner to the semi-intermediate student. The ten painting projects in this book will give you an in-depth study of different subjects, including techniques, applications, color mixing, composition, value studies, depth perception and much more. It does not matter if you are a beginner, an intermediate or even an advanced artist. These painting projects will surely inspire you to bring out the true artist that may be hidden in you. Painting is not only a great hobby, it is wonderful therapy to help us relax in this fast-paced push-button world. Also, keep in mind that while this book is very detailed in explaining different aspects of acrylic painting, I also have a toll-free number listed on page 3 you can call for additional technical support.

All the paintings in this book are designed as instructional paintings, and I hope each individual painting turns out to be a great success for you. Painting is a lifetime of learning, and all of the techniques and procedures you learn will truly enrich your life as an artist. Remember that you are the artist, so feel free to use your artistic license to make any changes you wish to help fulfill your artistic desires. My main goal in writing this book is to give you a good technical understanding of the painting process. So grab your brushes, paints and canvas and let's begin our adventure.

Painting Terms & Techniques

Before you get started on the step-by-step instructions on the following pages, it's a good idea to familiarize yourself with some of the terms, techniques and procedures that will be used. Take a few moments and study the following section. It will make your painting experience much more enjoyable.

COLOR COMPLEMENTS

Complements of colors are used to create color balance in painting. They are always opposite each other on the color wheel. It takes practice to understand the use of complements, but a good rule of thumb is to remember that whatever predominant color you have in your painting, use its complement or a form of its complement to highlight, accent or gray that color. For example, if your painting has a lot of green in it, the complement of green is red or a form of red, such as orange, red-orange or yellow-orange. If you have a lot of blue in your painting, the complement to blue is orange or a form of orange, such as yellow-orange or red-orange. The complement to yellow is purple or a form of purple. Each complement varies depending on which colors you use. It would be a good idea to pick up a simple color wheel at your local art store and familiarize yourself with all the different complements.

DABBING

Dabbing is mostly used to create leaves, ground cover, flowers, etc. You use a bristle brush and dab it on your table or palette to spread out the ends of the bristles like a fan. Then you load the brush with an appropriate color and gently dab on

To prepare your bristle brush for dabbing, spread out the end of the bristles like a fan.

appropriate color and gently dab on that color to create the desired effect. (See above example.)

DOUBLE LOAD OR TRIPLE LOAD

When you double or triple load your brush you put two or more colors on different parts of your brush. The colors are mixed on the canvas instead of your palette. This is used for wet-on-wet techniques, such as sky or water.

DRY BRUSH

The dry brush technique is achieved by loading your brush with very little paint and lightly skimming the sur-face of the canvas to add color, blend a color or soften a color. You use a very light touch for this technique.

FEATHERING

Feathering is a technique for blending to create very soft edges. You achieve this effect by using a very light touch and barely skimming the surface of the canvas with your brush. Feathering works great for highlighting and glazing.

GESSO

Gesso is a white paint generally used for sealing your canvas before you

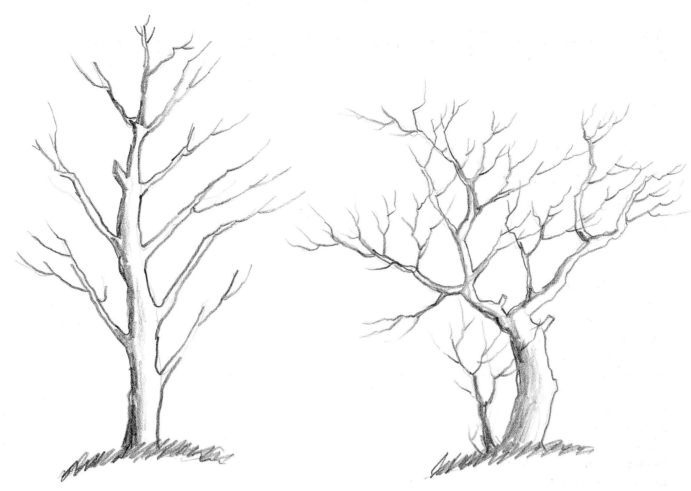

Here is an example of poor use of negative space. Notice the limbs do not overlap but are evenly spaced instead. There are few pockets of interesting space.

Here is an example of good use of negative space. Notice the overlap of the limbs and the interesting pockets of space around each limb.

begin painting. However, due to its creamy consistency, I often use it instead of white paint because it blends so much easier. I often refer to using gesso in mixing colors. Keep in mind when I use the word *gesso* I am referring to the color white. You don't have to use gesso for white but I prefer it to Titanium White, which is the standard white on the supply list. Please feel free to use it if you prefer.

GLAZE (WASH)
A glaze or a wash is a very thin layer of paint applied on top of a dry area of the painting to create mist, fog, haze or sun rays, or to soften an area that is too bright. This mixture is made up of water and a small amount of color. It may be applied layer on top of layer to achieve the desired affect. Each layer must be dry before applying the next.

HIGHLIGHTING (ACCENTING)
Highlighting is one of the final stages of your painting. Use pure color or brighter values of colors to give your painting its final glow. You usually apply highlights carefully on the sunlit edges of the most prominent objects in the painting.

MIXING
While this technique is fairly self-explanatory, there are a couple of ways to mix. First, if you know you need a particular color that you will use often, it is a good idea to premix that color and have it handy. I usually mix with my brush, but sometimes a palette knife works best. You can be your own judge. I also blend on the canvas. For instance, if I am underpainting grass I may put two or three colors on the canvas and scumble them together to create a muddled background or different colors. This also works well in skies. (**Note:** When mixing acrylics, always try to mix your paint to a creamy consistency. This really helps in blending or mixing colors.)

NEGATIVE SPACE
Negative space is an area or space that surrounds an object and gives it its form. (See above example.)

You can change the value of a color by adding white.

SCRUBBING

Scrubbing is similar to scumbling, except the strokes are more uniform in horizontal or vertical patterns. You can use drybrush or wet-on-wet techniques with this procedure. I mostly use it for underpainting or blocking in.

SCUMBLING

Scumbling involves using a series of unorganized overlapping strokes in different directions to create effects such as clumps of foliage, clouds, hair and grasses. The direction of the stroke is not important.

SOFTNESS

The most important aspect of acrylic painting is to soften the edges of each application of paint. Acrylics are transparent and are generally applied in layers. It is important that each layer has soft or feathered edges so the next layer will blend easily.

UNDERPAINTING OR BLOCKING IN

The first step in all paintings is to block in or underpaint the darker values of the entire painting. Then you begin applying the next values of color to create form and depth of each object.

VALUE

Value is the intensity of a color. Different values are used to create softness and to create depth in a painting. To achieve depth or distance, use lighter values in the background and darker values as you come closer to the foreground. You change the value of a color by adding white. (See above example.)

WET-ON-DRY

Wet-on-dry is the technique used most often in acrylic painting. When your background color is dry, apply the topcoat over it by using one of the blending techniques, such as dry brushing, scumbling or glazing.

WET-ON-WET

To achieve the wet-on-wet technique, blend colors together while the first application of paint is still wet. This technique is mostly used when using the large haké brush to blend large areas, such as skies and water.

Getting Started

This section will tell you what painting supplies and materials you will need to get started on the instructional paintings that follow.

A Word About Acrylics

The most common criticism about acrylics is that they dry too fast. Acrylics do dry very quickly through evaporation. To solve this problem I use a wet palette system, which is explained later in this chapter. I also use very specific drybrush blending techniques that make blending very easy. If you follow the techniques I use in this book, with a little practice you can overcome any of the drying problems acrylics seem to pose. Speaking as a professional artist, acrylics are ideally suited for exhibiting and shipping. You can actually frame an acrylic painting thirty minutes after you paint and it is ready to show or ship. You can varnish acrylics or leave them as they are because they are self-sealing. Acrylics are also very versatile. You can paint them to appear like oils or thin the paint with water and use them like watercolors. The best news of all is that acrylics are nontoxic, they have very little odor and few people have allergic reactions. Do not be intimidated by acrylics—just enjoy your painting experience.

USING A LIMITED PALETTE

As you will discover in this book, I work from a limited palette. Whether it is for my professional finished pieces or for instructional purposes, I have learned that a limited palette of the proper colors can be the most effective tool for painting.

This palette works well for two main reasons. First it teaches you to mix a wide range of shades and values of color, which every artist must be able to do. Second, a limited palette eliminates the need to purchase dozens of different colors. As we know, paint is becoming very expensive. So, with these few basic colors and a little knowledge of color theory you can paint anything you desire. This particular palette is very versatile, and with a basic understanding of the color wheel, the complementary color system and values, you can mix thousands of colors for every type of painting. This palette will work for portraits and figure work, birds and animals, landscapes, still lifes and many other subjects and atmospheric conditions. For example, you can mix Thalo Yellow Green, Alizarin Crimson and a touch of white to create a beautiful basic flesh tone. These same three colors can be used in combination with other colors to create beautiful earth tones for landscape paintings. Another example is to make black by mixing Ultramarine Blue with equal amounts of Dioxazine Purple and Burnt Sienna or Burnt Umber. The list goes on and on, and you will see that the sky is truly the limit. (**Note:** My selection of a limited number of specific brushes was chosen for the same reasons: versatility and economics.)

Palette

White Gesso

Grumbacher, *Liquitex* or *Winsor & Newton* paints
(color names may vary):

 Titanium White

 Cadmium Yellow Light

 Cadmium Orange

 Cadmium Red Light

 Hooker's Green

 Burnt Sienna

 Burnt Umber

 Ultramarine Blue

 Dioxazine Purple

 Alizarin Crimson

 Thalo Yellow Green

Brushes

2-inch (51mm) haké brush

no. 10 bristle brush

no. 6 bristle brush

no. 4 flat sable brush

no. 4 round sable brush

no. 4 script liner brush

Miscellaneous Items

Sta-Wet palette

Water can

Soft vine charcoal

16" x 20" (40.6cm x 50.8cm) stretched canvas

Paper towels

Palette knife

Mister bottle

Easel

Materials

The fewer colors and brushes you use, the less confused you become—especially if you are a beginner. You can mix any color or value in the world with these basic colors and paint any subject with these basic brushes.

You can purchase most of these supplies at any local art store. Some items may be harder to find depending on where you are located. There are several different brands of these items that you may want to use. I prefer Grumbacher paints, but Liquitex or Winsor & Newton are good products as well. Most paint companies make two grades of paints, a professional grade and a student grade. The professional grades are more expensive but much more effective to work with. The main thing is to buy what you can afford and have fun. (**Note:** If you can't find a particular item, I carry a complete line of professional- and student-grade paints and brushes for the convenience of all my students. Check page 3 for resource information.)

Brushes

2-INCH (51mm) HAKÉ BRUSH
The haké brush is a large brush used for blending. It is primarily used in wet-on-wet techniques for painting skies and large bodies of water. It is often used for glazing as well.

NO. 10 BRISTLE BRUSH
The no. 10 brush is used for underpainting large areas—mountains, rocks, ground or grass—as well as dabbing on tree leaves and other foliage. This brush also works great for scumbling and scrubbing techniques. The stiff bristles are very durable so you can be fairly rough on them.

NO. 6 BRISTLE BRUSH
A cousin to the no. 10 bristle brush, the no. 6 brush is used for many of the same techniques and procedures. The no. 6 bristle brush is more versatile because you can use it for smaller areas, intermediate details, highlights and some details on larger objects. The no. 6 and no. 10 bristle brushes are the brushes you will use the most.

NO. 4 FLAT SABLE BRUSH
Sable brushes are used for more refined blending, detailing and highlighting techniques. They work great for final details and are a must for painting people and detailing birds or animals. They are more fragile and more expensive, so treat them with extra care.

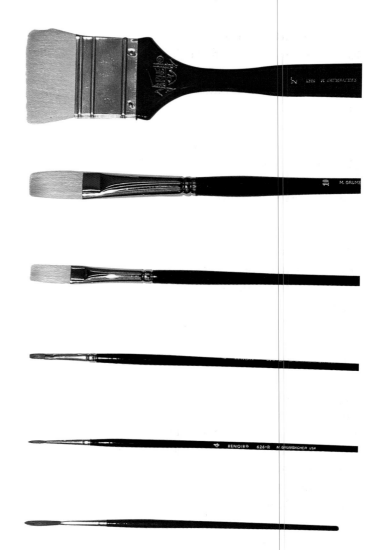

This is the basic set of brushes you will need to paint any subject.

NO. 4 ROUND SABLE BRUSH
Like the no. 4 flat sable brush, the no. 4 round sable brush is used for detailing, highlighting, people, birds, animals, etc. The main difference is that the sharp point allows you to have more control over areas where a flat brush will not work or is too wide. This is a great brush for finishing a painting.

NO. 4 SCRIPT LINER BRUSH
The script liner brush is used for the very fine details and narrow line work that can't be accomplished with any other brush. For example, use this brush for tree limbs, wire and weeds—your signature. The main thing to remember is to use a much thinner mixture of paint. Roll the brush in an inklike mixture until it forms a fine point.

BRUSH CLEANING TIPS

Remember acrylics dry through evaporation. If you allow paint to dry in your brushes or your clothes, it is very difficult to get it out. The solvent I use to get out dried paint is denatured alcohol. If you soak your brush in the alcohol for about thirty minutes and wash it out with soap and water, you can generally get the dried paint out. As soon as you finish painting, use good brush soap and warm water and thoroughly clean your brushes. Lay your brushes flat to dry.

Layout of Palette

There are several Sta-Wet palettes on the market. The two I use extensively are made by Masterson. Keep in mind acrylics dry through evaporation, so keeping your paints wet is critical. The first palette is a 12" × 16" (30.5cm × 40.6cm) plastic palette saver box with an air-tight lid. It seals like Tupperware. This palette comes with a sponge you saturate with water and lay in the bottom of the box. Next you soak the specialty palette paper and lay it on the sponge. Place your paints out around the edge and you are ready to go. Use your mister bottle to occasionally mist your paints and they will stay wet all day long. When you are finished painting attach the lid and they will stay wet for days.

My favorite palette is the same 12" × 16" (30.5cm × 40.6cm) palette box, except I don't use the sponge or palette paper. Instead I place a piece of double-strength glass in the bottom of the palette. I fold paper towels into long strips (into fourths) and saturate them with water. I lay them on the outer edge of the glass. I place my paints on the paper towel. They will stay wet for days. Occasionally mist them to keep the towels wet.

If you leave your paints in a sealed palette for several days without opening it certain colors, such as, green and Burnt Umber will mildew. Just replace the color or add a few drops of chlorine bleach to your water to help prevent mildew.

To clean the glass palette, allow it to sit for about thirty seconds in water or spray the glass with your mister bottle. Scrape off the old paint with a single-edge razor blade. Either palette is great. I prefer the glass palette because I don't have to change the palette paper.

Chisel Corner

Tip

Chisel Edge

Flat Side

Metal Ferrule

Handle

Brush diagram

Setting Up Your Palette

Here are two different ways to set up your palette.

Palette 1

The Sta-Wet 12" × 16" (30.5cm × 40.6cm) plastic palette saver box comes with a large sponge. Saturate the sponge in water.

Lay the sponge inside the palette box. Next, soak the specialty palette paper and lay it on the sponge. Place your paints around the edge. Don't forget to occasionally mist your paints to keep them wet.

The palette comes with an airtight lid that seals like Tupperware.

When closing the palette saver box, make sure the lid is on securely. When sealed, your paints will stay wet for days.

Palette 2

Instead of using the sponge or palette paper, another way to set up your palette box is to use a piece of double-strength glass in the bottom of the palette. Fold paper towels in long strips and saturate them with water. These will hold your paint.

Lay the saturated paper towels on the outer edge of the glass.

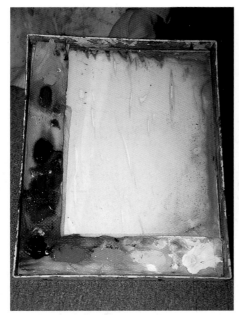

I place my paints on the paper towel in the order shown.

Use the center of the palette for mixing paints. Occasionally mist the paper towels to keep them wet.

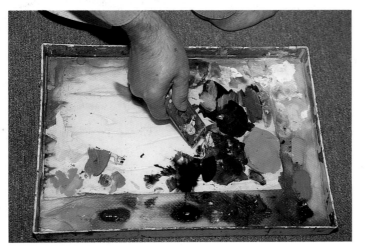

To clean your palette, allow it to sit for thirty seconds in water or spray the glass with your mister bottle. Scrape off the old paint with a single-edge razor blade.

Miscellaneous Supplies

Canvas

There are many types of canvas available. Canvas boards are fine for practicing your strokes, along with canvas paper pads for doing studies and testing paints and brush techniques. The best surface to work on is a preprimed, prestretched cotton canvas with a medium texture. This can be found at most art stores. As you become more advanced in your skills, you may want to learn to stretch your own canvas. I do this as often as I can, but for now a 16" × 20" (40.6cm × 50.8cm) prestretched cotton canvas is all you need for the paintings in this book.

Easel

I prefer to work on a sturdy standing easel. There are many easels on the market, but my favorite is the Stan-Rite ST 500 aluminum easel. It is lightweight, sturdy and easy to fold up and take on location or to workshops.

Lighting

Of course the best light is natural north light. Most of us don't have this light available to us. The next best light is 4' or 8' fluorescent lights hung directly over your easel. Place one cool bulb and one warm bulb in the fixture: This best simulates natural light.

Studio lights

16" × 20" (40.6cm × 50.8cm) stretched canvas

Aluminum Stan-Rite studio easel

Mister Bottle

I use a mister bottle with a fine mist to lightly mist my paints and brushes throughout the painting process. The best misters are usually plant misters or mister bottles from a beauty supply store. It is a must to keep one handy.

Palette Knife

I do not do a lot of palette-knife painting. I mostly use a knife for mixing. A trowel-shaped knife is more comfortable and easier to use than a flat knife.

Soft Vine Charcoal

I prefer to use soft vine charcoal for most of my sketching. It is very easy to work with and shows up well. It is easy to remove (or make changes) by wiping it off with a damp paper towel.

Mister bottle

Soft vine charcoal

Palette knives

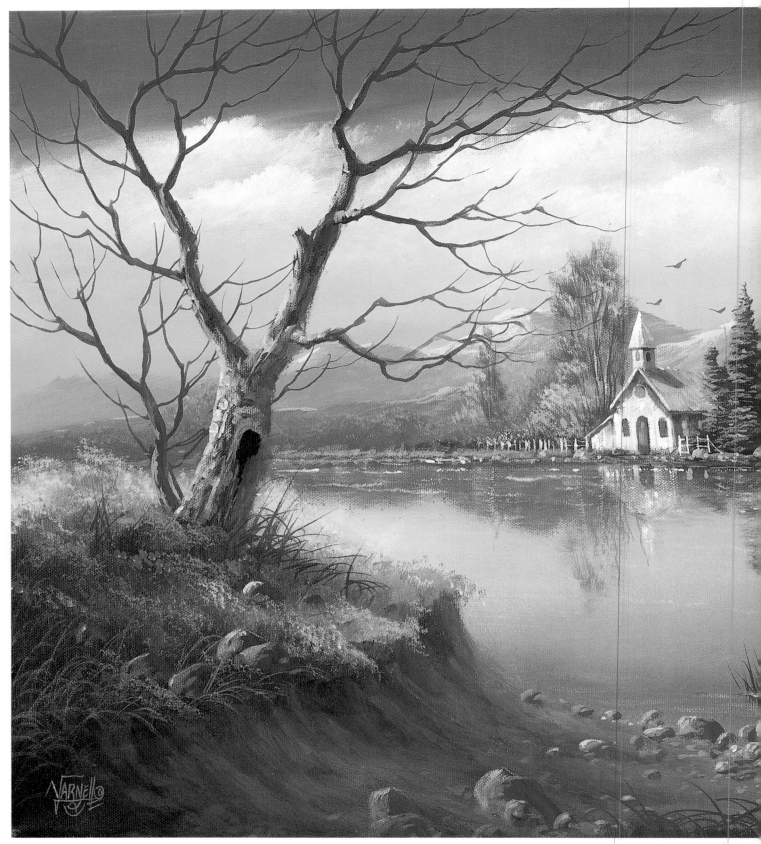

Church in the Wildwood
16" x 20" (40.6cm x 50.8cm)

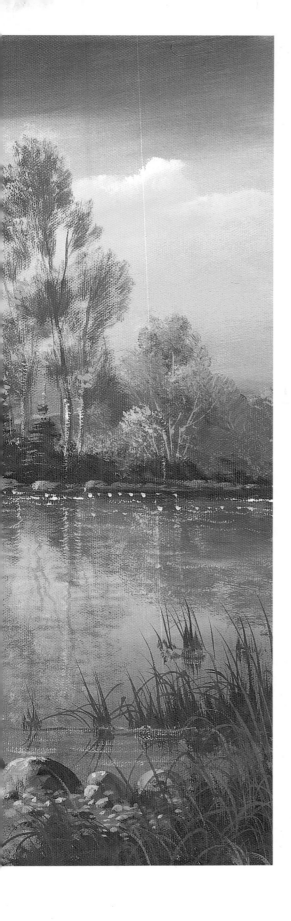

Church in the Wildwood

This is a wonderful painting full of many distinct elements to challenge the creative process. I chose this particular painting because it demonstrates good examples of value change, color change, multiple subjects, design and composition. This painting utilizes most of the painting techniques we have discussed. You will use all the brushes and a full range of colors from your palette. This is an excellent all-around learning painting—and great fun to create.

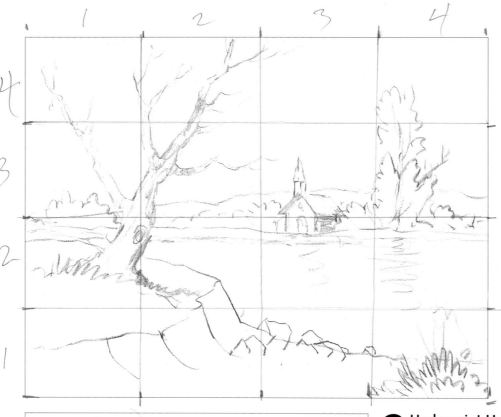

4 3/8

1 Create Basic Charcoal Sketch

I always begin with a rough charcoal sketch of the basic contour lines of the landscape. Don't spend too much time on sketching, and remember to use soft vine charcoal: It easily wipes off if you need to make changes.

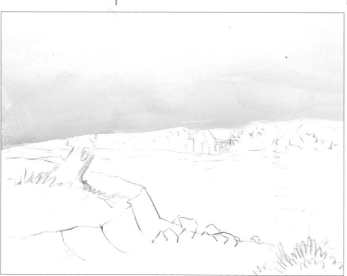

2 Underpaint Horizon

Lightly wet the sky area with your misting bottle or apply a thin wash with your haké brush. Immediately apply a liberal coat of gesso using your haké brush. Be sure to cover every inch of the sky, making sure it's an opaque coverage and not a wash. While the gesso is still wet, apply a small amount of Cadmium Orange at the horizon and gradually blend it upward using large *X* strokes until the orange disappears.

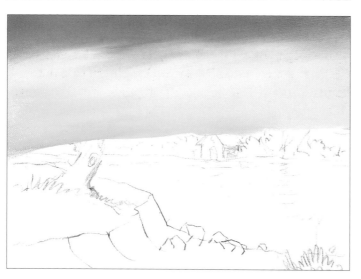

3 Underpaint Top of Sky

While your sky is still wet, take a dab of Ultramarine Blue on one corner of your haké brush and a small dab of Dioxazine Purple on the other corner. Apply the two colors across the top of the sky in a horizontal motion. The two colors should blend together. Using large *X* strokes, blend the colors downward until they gradually fade into the whitish orange mixture at the horizon. At this point I rinse my brush of excess paint and smooth out any rough areas using large. light feather strokes.

4 Underpaint Water

For the water area, follow the same exact steps that I used for the sky. The only difference is that the location of the colors is reversed. The orange-and-white mixture is at the top of the water and the blue-and-purple mixture is at the bottom. This gives a more accurate reflection of the sky colors. (**Note:** It is a good idea to always paint your sky and water at the same time. This makes for better color continuity.)

5 Block In Distant Hills

Now I begin to paint the first two values of the distant mountains. You can use your haké brush, which I prefer because of its flexibility, or you can use a no. 6 bristle brush. I use gesso, a touch of purple, a touch of blue and a little touch of Burnt Sienna. Mix this value so it is slightly darker than your sky. Block in the first layer of mountains, creating interesting shapes with negative space. Then darken (or increase the value) of the color by adding just a touch more of Burnt Sienna, purple and blue. You want this color to be only slightly darker. Next scrub in the next layer of smaller mountains.

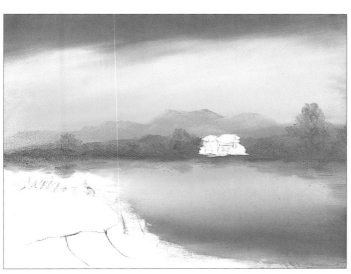

6 Block In First Layer of Distant Trees

Block in the distant trees using a no. 10 bristle brush. Begin with a little gesso, a touch of Hooker's Green and a touch of Dioxazine Purple, mixing these paints together to create a soft greenish gray. The value should be slightly darker than the last layer of mountains. Load your brush evenly and block in your trees with an upward scrubbing motion, twisting the brush in your fingers to create different shapes. Keep the edges of your trees soft. Also scrub in a little color in the water to suggest the beginning of reflections.

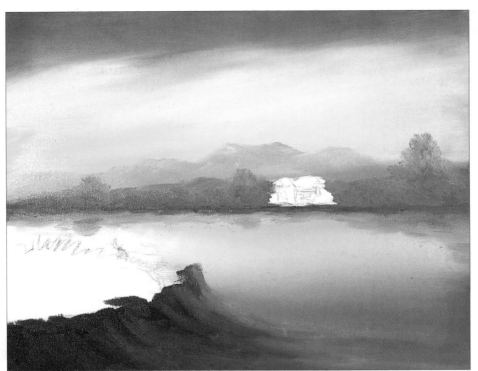

7 Underpaint Foreground Shoreline

For this simple step I use my no. 10 bristle brush. First mix Burnt Sienna and Dioxazine Purple and then start at the top of the bank using short, choppy comma strokes. As you come down to the flat area, use long horizontal strokes and add a touch of white and orange until you have covered the rest of the canvas. Be sure to keep your strokes loose and free. Do not smooth everything out: It appears more like dirt if you keep your strokes rough.

8 Underpaint Foreground Grass

To underpaint the foreground grass, use thick paint to get the right results. Use a no. 10 bristle brush to scumble on a thick layer of yellow at the top of the grass area. While the yellow is still wet, begin adding green, Burnt Sienna and touches of purple and orange. Don't blend everything together or it will turn into one color. Beginning at the top of the yellow, place your brush flat against the canvas and push up and pull back. Work quickly and move across the canvas. Repeat the stroke as you move down. Keep adding yellow, Burnt Sienna, purple and orange in thick layers, making it darker as you come forward. Keep repeating the technique of pushing up and pulling back until all the grass is blended together.

9 Drybrush Clouds and Highlight Distant Mountains

To paint the clouds and highlight the mountains, mix gesso and a touch of orange. Only slightly tint the white. Load a small amount of the creamy mixture on a no. 6 bristle brush and scumble the clouds on with a loose, dry brushstroke. Make sure to allow the bottom edge of each cloud to fade out into the background. Arrange the cloud formations so they have good flow and good design: Do not repeat the same shape over and over. For the highlights on the mountains, simply load a small amount of the creamy white cloud mixture on the tip of your brush and drybrush from the top of the mountain, angling down leftward using choppy irregular strokes.

10 Define Shoreline and Reflections

Now you can strengthen the reflections and highlight your trees. First mix Hooker's Green, a touch of purple and white to create a greenish gray. Smudge a strip of this color along the shoreline with short, choppy strokes using a no. 6 bristle brush. While the shoreline is wet, pull the reflections of the trees down into the water. Use a very scrubby dry brushstroke to create the reflections. Now add yellow and white to the mixture to create a greenish highlight. With your no. 6 brush, gently dab on the highlights on the left side of the trees.

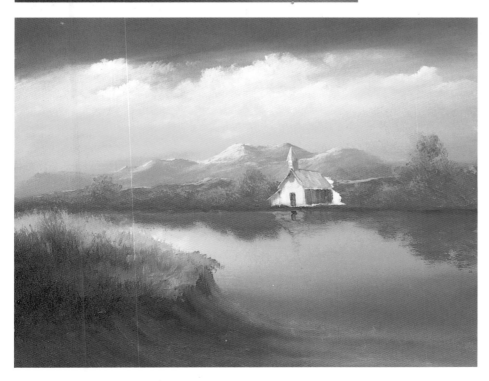

11 Block In Church

Now block in the church with the no. 6 bristle brush. First mix white with Burnt Sienna and a touch of Ultramarine Blue. This will be the base color. Use a vertical stroke to block in the dark side of the church. Then add more white to create a light gray and block in the light side of the church and steeple.

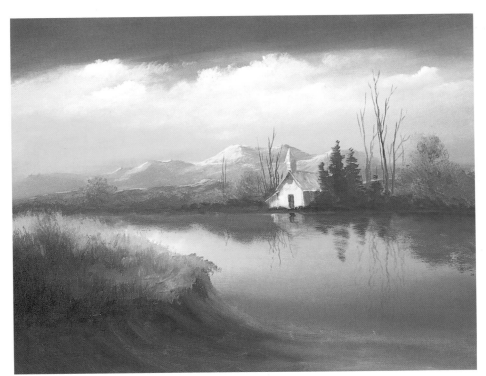

12 Block In Middle-Ground Trees and Reflections

Now you can block in the pine trees and the trunks of the large trees. Mix Hooker's Green, Dioxazine Purple and a touch of white. Dab on the pine trees, giving them a nice design with good negative space. At the same time drybrush their reflections in the water. Next add plenty of water to create a very thin mixture. Using your no. 4 script liner brush, start at the base of each trunk and move upward, gradually decreasing pressure on your brush until you create nicely tapered trunks and limbs.

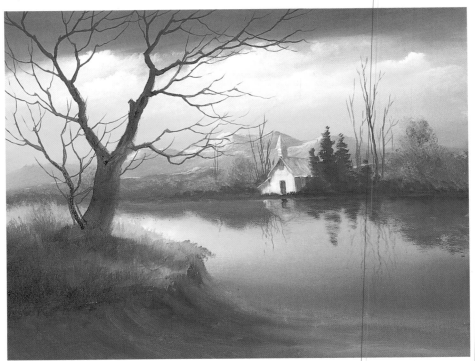

13 Underpaint Foreground Tree

One of my favorite things to paint is large dead trees. You can sketch in your tree with charcoal or create it as you go. Using pure Burnt Umber and your no. 6 bristle brush, block in the main body of the tree but not the small limbs. After the main body is finished, go back to your script liner brush and, using a very watery mixture of the Burnt Umber, paint the smaller limbs from the trunk outward. Use a light touch. (**Note:** Never paint the limbs from the outside toward the body of the tree. You will create a much nicer tapered limb by painting from the tree outward.)

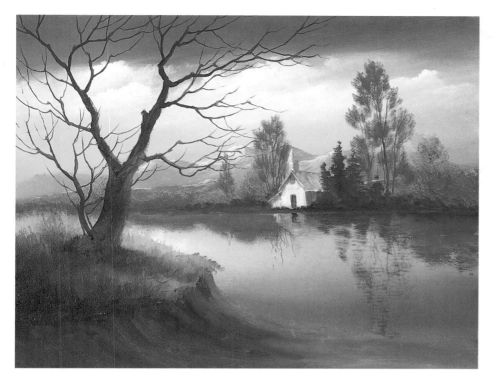

14 Underpaint Large Middle-Ground Trees

Using a no. 6 bristle brush, mix Hooker's Green, Burnt Sienna and a touch of yellow, plus a small amount of white. With choppy dry brushstrokes, block in the leaves of the middle-ground tree trunks. Keep the edges of the trees soft: Be sure you leave interesting pockets of negative space. Smudge in the reflections.

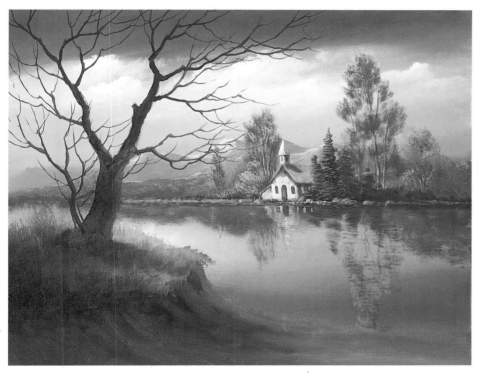

15 Highlight Middle Ground

In this step you will highlight the middle-ground trees, shoreline and church. First mix yellow and white for the large trees. Using the no. 6 bristle brush, dab the highlight on the left side of the trees. Be sure not to cover all of the underpainting color. Smudge a little of this color in the water. Now add white and blue to the mixture for the highlights. Dab highlights on the pine trees so some dark values still show through. Now add more white and orange to the mixture and switch to the no. 4 flat sable brush. Put little dabs along the shoreline to suggest rocks. Now brighten the church with more white. Mix yellow and orange for the light in the windows. Whatever you do above the water should be repeated by smudges of those same colors in the water. This will improve the reflective quality of the water.

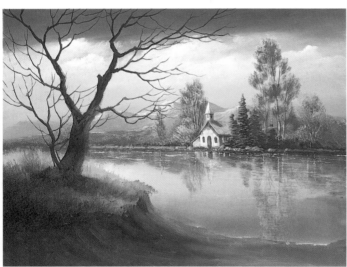

16 Glaze Water

Now you will glaze the water. For this step, mix a very thin wash of gesso and water. Take the haké brush and load it evenly. Drag the brush carefully across the surface of the water, barely touching the surface of the canvas. This will leave a thin film that helps soften the reflections. Take your script liner brush and, using a little gesso, streak on some thin highlight lines horizontally.

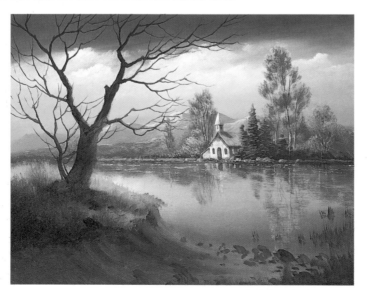

17 Underpaint Rocks and Foreground Grasses

For the rocks mix Burnt Umber, Ultramarine Blue, a touch of purple and white. Use your no. 6 bristle or no. 4 flat sable brush and block in the shadowed side of each rock. Add Hooker's Green to the same mixture, and using the no. 6 bristle brush, drybrush the grass formations using an upward motion.

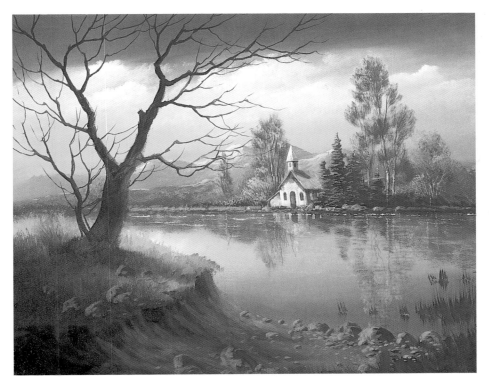

18 Highlight Rocks and Foreground Bank

Mix a sunshine color of white with a touch of orange. A touch of purple will tone it down. With the no. 4 flat sable brush, gently paint in the highlights on the rocks. By adding a touch more orange to the mixture, you can drybrush some highlights on the bank and flat ground. This is a good time to smudge this color up against the rocks to settle them down.

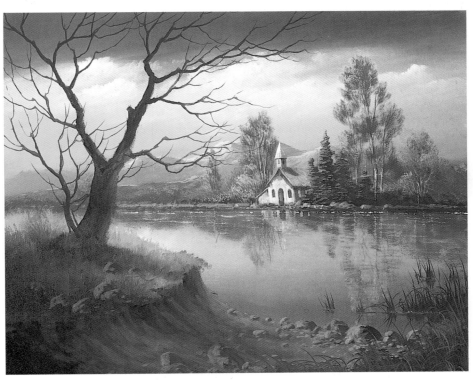

19 Paint Tall Foreground Weeds

In this simple step you add the taller weeds in the foreground. Mix a highlight color of your choosing and add plenty of water to make it very thin. Use your script liner brush and load it fully. Using a circular motion, lightly touch the canvas, angling toward the center of the canvas. Put in as many weeds as you feel comfortable with. You can use dark- or light-colored weeds depending on where you place them. Paint light against dark or dark against light.

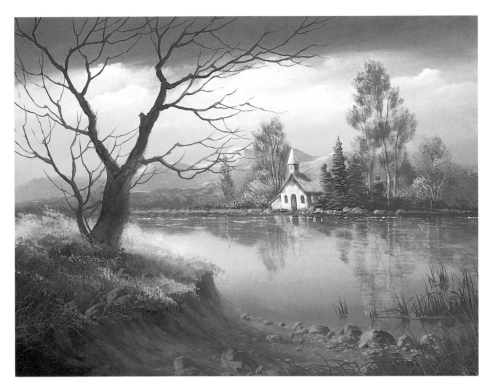

20 Add Flowers and Ground Cover

For the flowers and highlights on the grassy bank, mix two or three of your favorite colors. Make the mixture creamy by adding water. Be careful not to make it too thin. Now take the no. 10 bristle brush and rough up the tips of the bristle. Load a small amount of paint on the tip of the brush and lightly touch the canvas, scattering the flowers around the base of the tree. Clean your brush and repeat the process with another color.

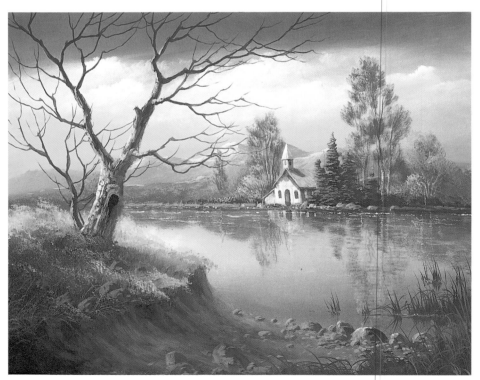

21 Highlight Tree and Bark

To put bark on the tree you will use the no. 4 flat sable brush. Mix gesso, a touch of orange and a touch of yellow. Turn your brush vertical to the tree and use short, choppy vertical strokes to create the texture on the left side of the bark. Be careful not to cover up the background. The dark-light contrast is important to making the tree look round. Now mix white, a touch of blue and purple for the reflected highlight. Using the same stroke gently drybrush this color on the right side of the tree. Use a no. 4 round sable brush to highlight smaller limbs.

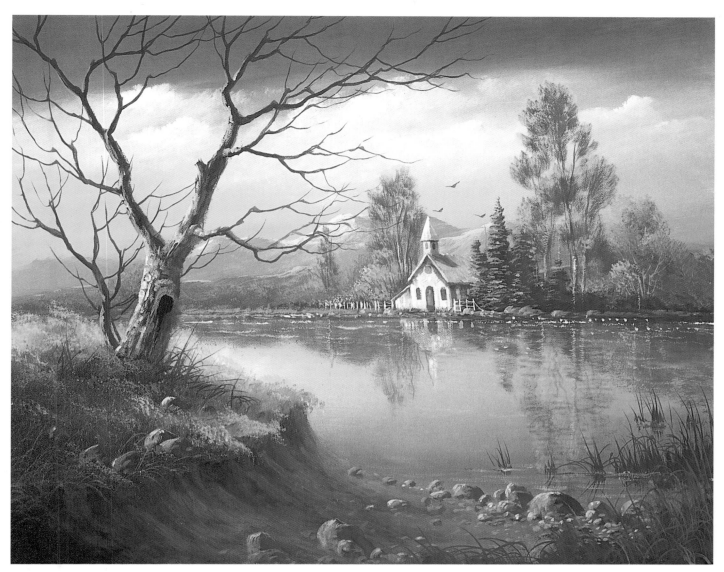

22 Add Final Details and Accent

Accenting the painting is very often an optional step. At this point your painting may be finished, or perhaps it needs minor adjustments. What I normally do is stand back about six feet (182.9cm) and study the painting for unfinished areas or problems. Then I make the necessary corrections. In this example I simply brightened the highlights on the rocks, added distant birds and added minor accents on the water and trees. Remember my motto, "The three P's: don't piddle, play or putter." When it's done you're done.

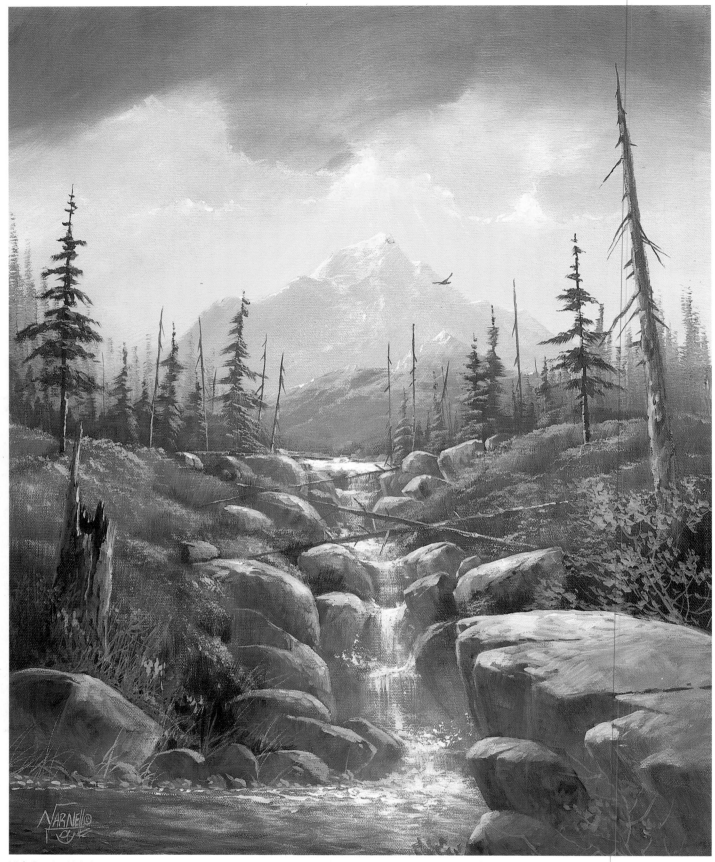

High Country Majesty
20" x 16" (50.8cm x 40.6cm)

High Country Majesty

Waterfalls have always been one of my favorite subjects to paint. As intimidating as they may look, painting them is not nearly as difficult as it may seem. I chose this painting and subject mainly to help you create depth by graduating colors. In addition, this painting also demonstrates how to paint large rocks and boulders and falling or running water. Rocks have always been a challenge for most artists. If you follow the steps carefully and be patient with yourself, you will master the art of rock painting. Remember this painting is designed for instructional purposes, so don't worry if you can't paint notable rocks at first. Keep trying!

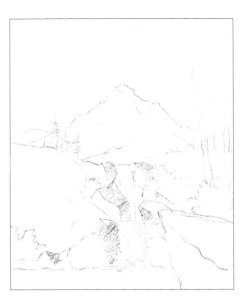

1 Create Rough Sketch

Begin with a light charcoal sketch of the main components of the composition.

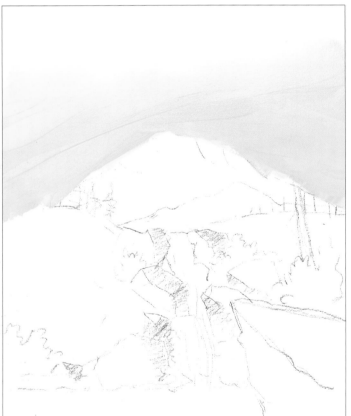

2 Underpaint Sky and Horizon

Lightly wet the sky with your haké brush and then apply a liberal coat of gesso, completely covering the entire sky. While the gesso is wet, apply pure Cadmium Yellow Light at the bottom of the sky and blend it upward until the yellow fades out.

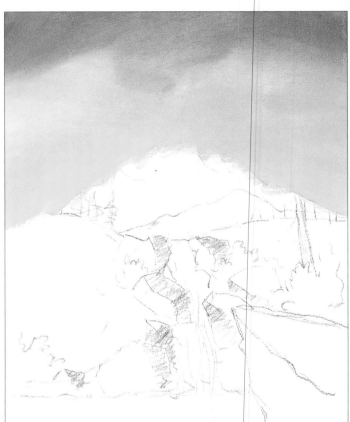

3 Finish Sky

While the sky is still wet, using Dioxazine Purple with the haké brush, begin at the top and blend, moving downward using crisscross motions until you reach the yellow. Be careful to leave pockets of light and dark contrasts to create the suggestion of cloud formations.

4 Underpaint Distant Mountains

Continue with the haké brush and mix white with a touch of purple and blue. Keeping the mixture very light, gently block in the first layer of distant mountains. Make sure they have an interesting shape. Now darken the mixture with a little purple, a touch of blue and Burnt Sienna. Make sure the color is on the purple side. Now block in the middle-ground mountains with the no. 6 bristle brush, giving them an interesting shape.

5 Underpaint Distant Pine Trees

Now continue, using the haké brush by turning it vertically. First take your mountain color and add a touch more purple and Hooker's Green. Be sure the mixture is creamy. Using the chiseled edge of the haké brush, gently dab in the distant pine trees. Use a short, choppy stroke and be sure your trees have different heights.

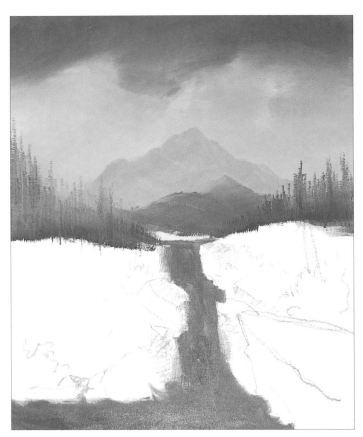

6 Underpaint Waterfall

This step is fairly simple. All you need to do is underpaint the area for the waterfall by mixing white with a touch of purple and blue. Use your no. 10 bristle brush for this step. Smudge in areas of darkness where rock formations are likely to be. Don't be afraid to be very loose and free with your strokes.

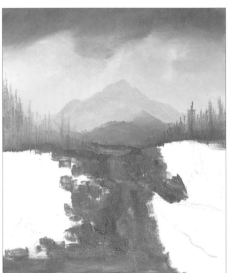

7 Underpaint Rock Formations

Now underpaint the rock formations using a mixture of white, purple, blue and Burnt Sienna. I like to use my no. 10 bristle brush and smudge in areas of darkness where the rock formations are more likely to be. Do not be afraid to be very loose and free with your strokes.

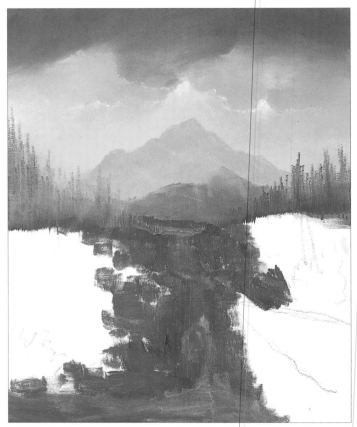

8 Highlight Clouds

Now highlight the cloud formations. First mix white with yellow. Make sure the mixture is very creamy. Take your no. 4 round sable brush and paint the silver lining on the bottom of each cloud formation. Place the paint on thick so it will be opaque and bright. Then paint in the sun at the break in the cloud formation. Switch to the no. 6 bristle brush and drybrush some of the sun color downward to create the effect of soft sun rays from the clouds. Be sure to use very light feather strokes.

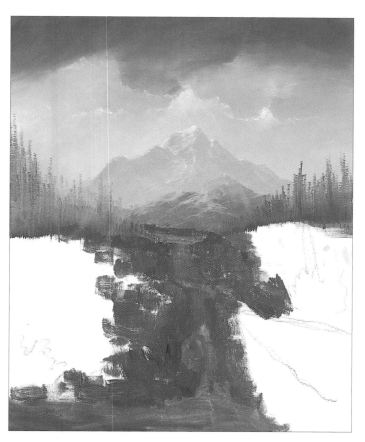

9 Highlight Distant Mountains

For highlighting the mountains, mix white with only a touch of yellow. With your no. 4 flat sable brush, use short, choppy strokes in a left-downward motion. Be sure to leave pockets of negative space to create ridges and valleys in the mountains. Do not use too much paint: The highlights need to be soft and distant. For the next layer of mountains, simply add a touch of orange to the highlight mixture and repeat the same strokes.

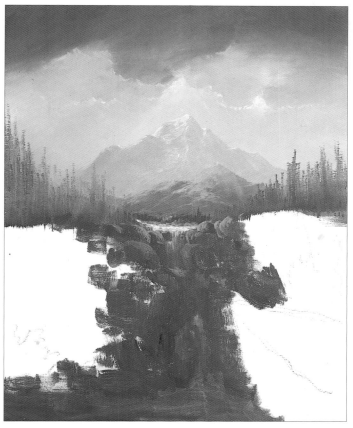

10 Highlight Back Rocks and Top of Waterfall

At this point you will highlight the background rocks and water. First mix white with a touch of orange and a small touch of yellow. Using your no. 4 flat sable brush, gently drybrush on the highlights of the background rocks. (Do not over-highlight.) Dab pure white onto the top of the waterfall using a horizontal stroke. Put the paint on thick so it will appear opaque.

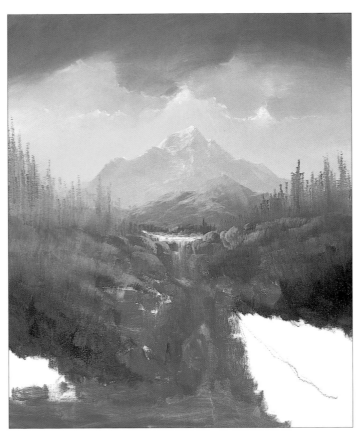

11 Underpaint Mountain Meadow

Now block in the mountain meadow using the no. 10 bristle brush. On each side of the waterfall lay on yellow, Hooker's Green and touches of Burnt Sienna. Do not premix the paints: Scumble them together on the canvas, making sure the paint is thick. (Do not blend paints together.) While the paint is wet put your brush flat against the canvas. Start at the top of the grass and push upward, moving across your canvas. Move downward to the next row of paints, pushing this layer of paint up, overlapping the row above. Repeat this process all the way down to the bottom of the canvas. Make sure you add darker colors—green, purple and Burnt Sienna—as your move downward. Have fun creating different light and dark values of grass.

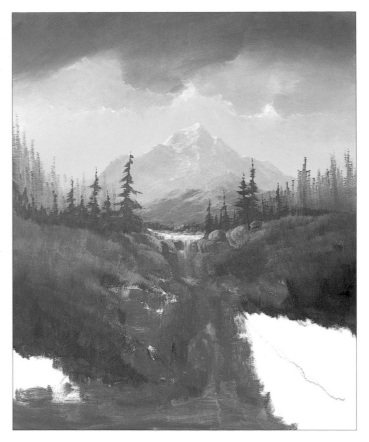

12 Block In Middle-Ground Pine Trees

First mix purple, a touch of green and the proper amount of white. Take your no. 6 bristle brush and dab in the pine trees. Again remember to not make each tree the same height, size and shape. Keep the strokes quick and choppy, and lay the paint on thick. Practice using different parts of the brush to create different shapes.

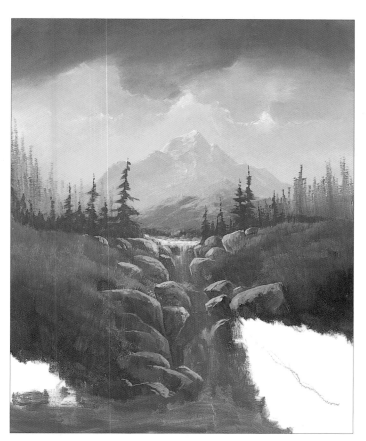

13 Highlight Middle-Ground and Foreground Rocks

Now you will finish highlighting the middle-ground and foreground rocks. First mix white with a touch of orange and yellow. Then you can use either the no. 6 bristle or the no. 4 flat sable brush, or both. Take a little dab of the sunshine color and dry-brush on the highlight beginning at the top of each rock. Stroke downward with a feather stroke so some of the background still shows through. Repeat this process two or three times on each rock until you are pleased with the brightness of the highlight. Start with the rocks farthest away and then move forward.

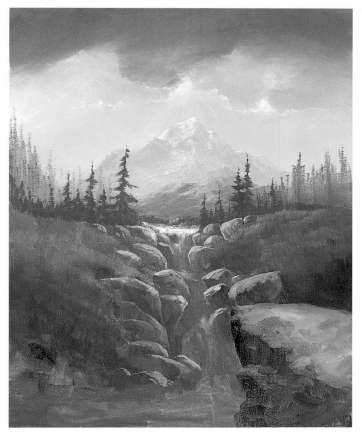

14 Underpaint Large Foreground Rock

Block in the foreground rock and the bank on the water's edge. Mix Burnt Sienna and purple and use a no. 6 bristle brush. Use short, choppy strokes in different directions to block in the dark areas of the rock and bank. Next, add white and a touch of orange to the mixture to highlight the top of the rock. Again, use short, choppy strokes. Do not paint it a solid color: Leave dark and light areas.

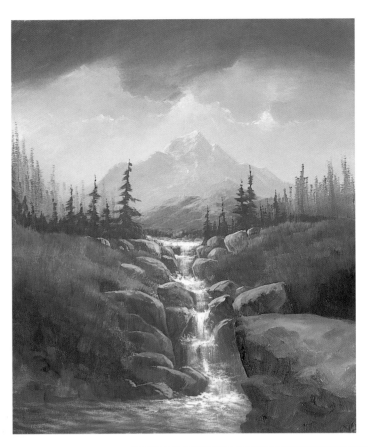

15 Highlight Waterfall

In this step you will drybrush on the highlights of the waterfall. Mix white with a very small amount of yellow. I prefer to use the no. 6 bristle brush, but you could use the no. 4 flat sable. The paint should be very creamy. Using a light touch, drybrush over the background and edges of the rocks: Do not completely cover the background. This effect will create depth in the water. When you reach the smooth or still area of the water, use a horizontal choppy stroke to create the ripples.

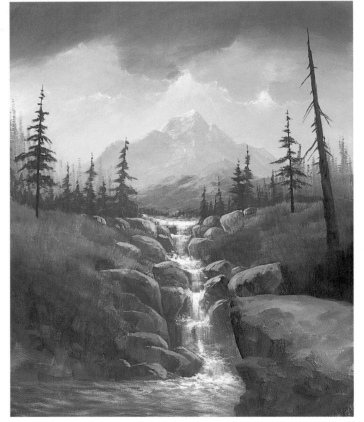

16 Block In Large Pine Trees

Now it is time to block in the larger pine trees and the dead pine tree. First mix Hooker's Green and a touch of purple. With your no. 6 bristle brush, dab the thick paint onto the trees using the very tip of the brush. Make the trees interesting by allowing the background to show through. Then block in the large dead tree with the same brush turned vertically. Use the same color mixture and the no. 4 round sable brush to paint in the trunks of the pine trees.

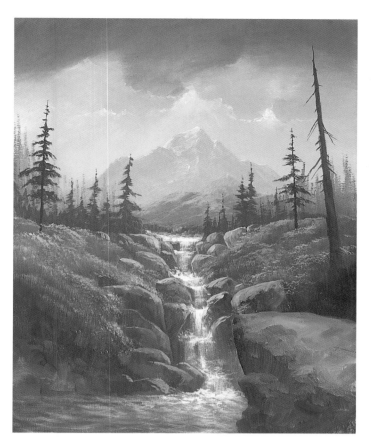

17 Highlight Grasses

This step is exciting. Mix pure yellow with a touch of orange. Take the no. 10 bristle brush and fluff the ends of the bristles by flattening them on a solid surface: This separates the bristles to help create texture. Now load the brush heavily and dab straight onto the canvas with a light touch. Follow the contour of the land. Reload often and let some background come through to create depth of field.

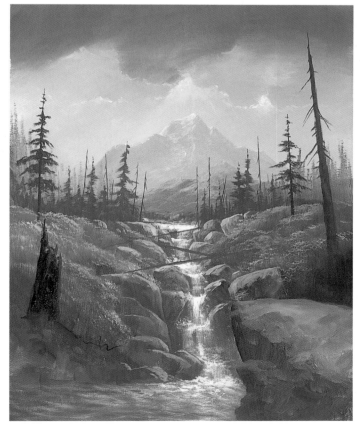

18 Underpaint Tree Stump

This step is simple. Mix Burnt Umber with a touch of blue and purple and block in the dead tree stump. Then add a bit more white and block in the fallen trees across the waterfall. You can also add some of this darker value to your larger rocks if necessary.

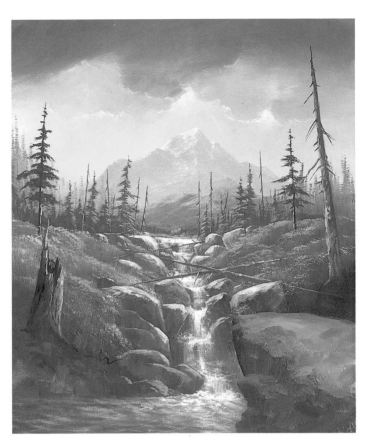

19 Highlight Tree Trunks

Mix a sunshine color of white, orange and a touch of yellow. Use your no. 4 flat sable brush to create the texture of bark. The strokes should be short, choppy, and vertical. Be sure to leave plenty of dark background showing through to create depth in the bark. Repeat this step two or three times if necessary to get the brightness you want.

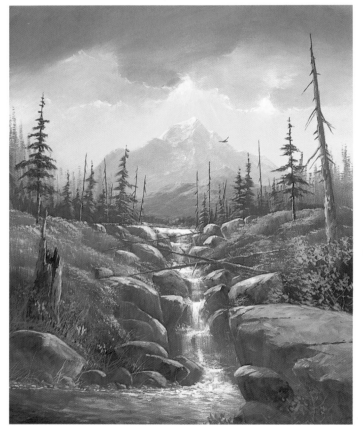

20 Add Final Details and Highlights

In this step you will add final details and highlights. For example, flowers are done with pure color and your no. 6 bristle brush. Pick the best color for your painting—red, yellow, orange, purple, etc.—and dab it straight on to create the texture of flowers or foliage. Use white and orange for all the miscellaneous highlights, such as the bark on trees and accenting rocks. Use whatever brush best fits the object and is most comfortable for you. For very small details, use your script liner brush. Use an inklike consistency of the appropriate color for weeds, trees, limbs, etc. Have fun experimenting.

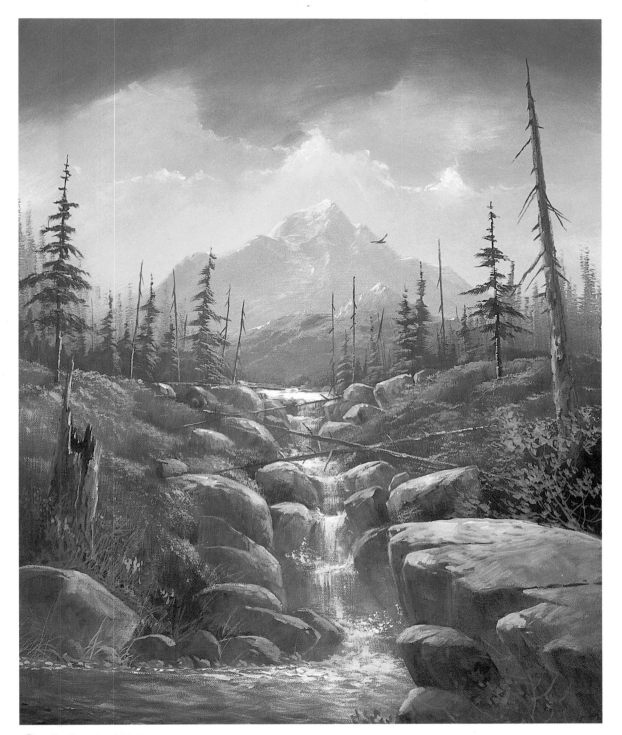

21 Create Mist

This is an optional step. You can mist or fog the lower, middle-background mountains. To achieve this effect, mix a very thin wash of water, a touch of white, purple and blue. This is called a glaze. Now take a no. 6 or no. 10 bristle brush and smudge the glaze over the mountain and background trees, creating a soft hazy effect. After it dries you can repeat this step, making the fog or mist as dense as you like.

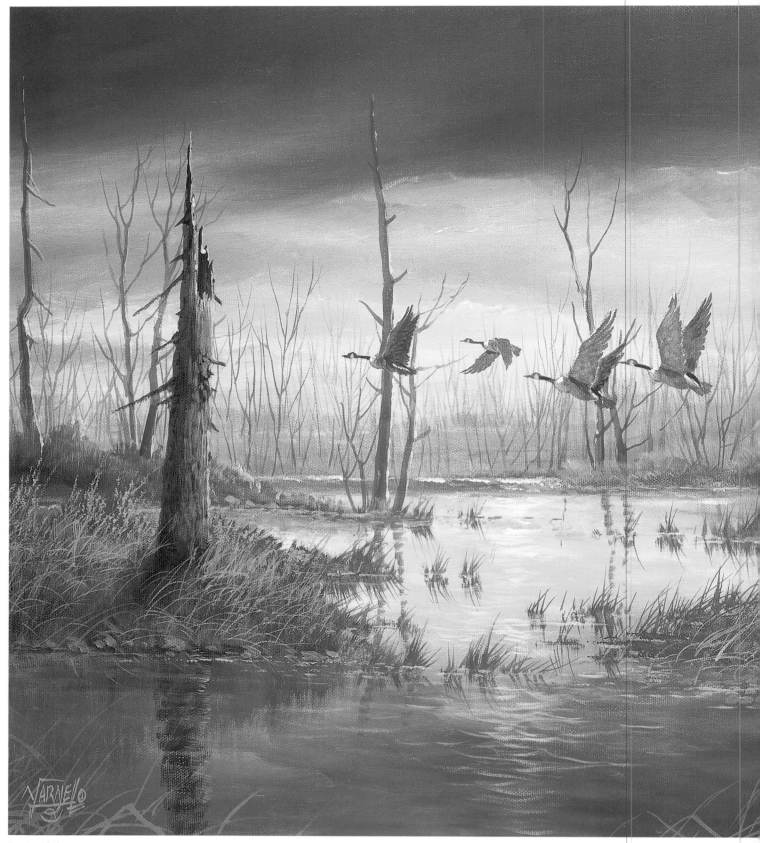

Evening Flight
16" x 20" (40.6cm x 50.8cm)

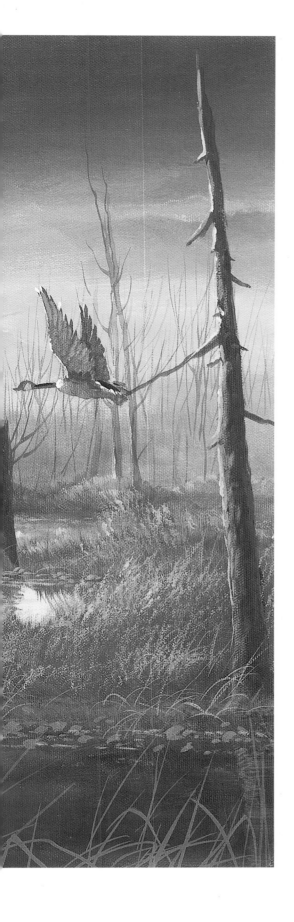

Evening Flight

In this painting what may appear to many as a wasteland of dead trees, an artist sees as a wonderful study in design and character. Arranging the trees so you have a good balance of negative space and good composition is a challenge. Adding a beautiful glowing sunset, glistening water and a flock of Canadian geese looking for a place to land will test your artistic abilities and imagination. However, this is not a difficult painting. I designed this painting specifically to give you experience with leafless trees and water reflections, and an opportunity to try your hand with some wildlife. So let's get started!

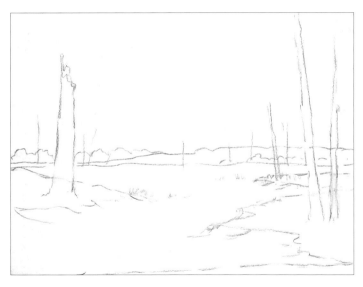

1 Draw Rough Sketch

Take your soft vine charcoal and sketch in the main components of the landscape. We will paint over most of the sketch; the purpose of this is to help you fix in your mind where the main subjects will be placed.

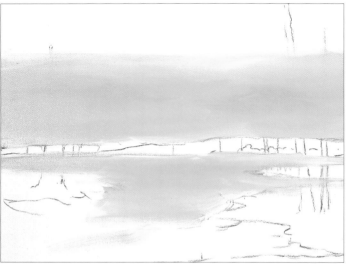

2 Underpaint Sky, Horizon and Water

Lightly wet the sky area with water using your haké brush. You will underpaint the water and sky at the same time. Apply a liberal coat of gesso with your haké brush. While the gesso is wet, add yellow and a touch of orange. Blend these colors horizontally, leaving light and dark areas in the sky area.

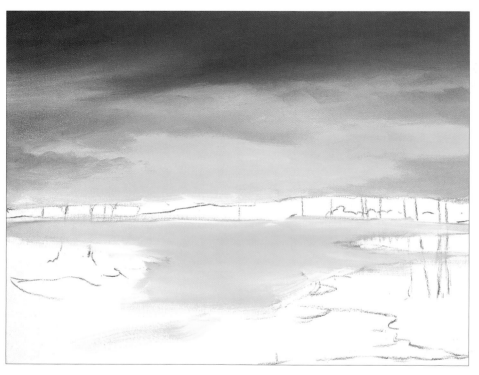

3 Underpaint Top of Sky

While the background is wet, load blue and purple on the corners of your haké brush. Streak your brush across the top of the sky horizontally, adding more color as needed to darken it. You can add a small amount of Burnt Sienna to gray the color. Now use long horizontal strokes to blend in the sky. Do not blend everything smooth. Notice that the light and dark pockets give the suggestion of moving clouds: Make sure all blended edges are soft.

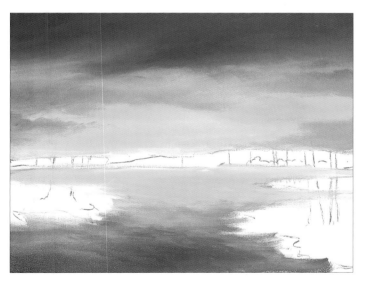

4 Underpaint Foreground Water

You will repeat the same procedure you used in the dark part of the sky in the water area. You may switch to a no. 10 bristle brush for this step. Use short, choppy strokes to suggest moving water. Be sure to put gesso underneath your base color to allow for smooth blending. Remember that you are reflecting the sky color into the water.

5 Underpaint Background

Use your no. 10 bristle brush and mix white with a touch of purple. Scumble in the background landscape, keeping the edges soft. You want to create the suggestion of distant trees and a hill. This will also create depth in your painting.

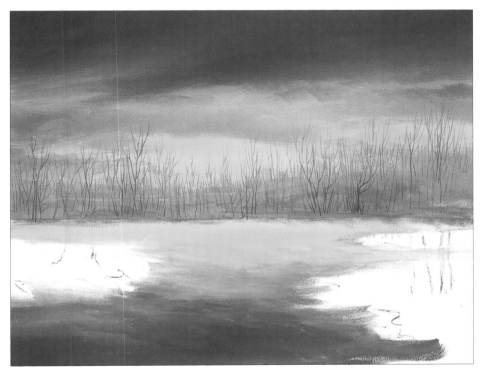

6 Add Background Trees

In this step you will use the same mixture of paint you used in the previous step. Add a touch more purple and Burnt Sienna to darken the mixture. Thin the mixture with water until it becomes inklike. Use your no. 4 script liner brush and load it with the inky mixture. Roll the tip of the brush to a point. Begin at the base of each tree and move upward, creating small delicate limbs. Place numerous distant trees across the back of the horizon.

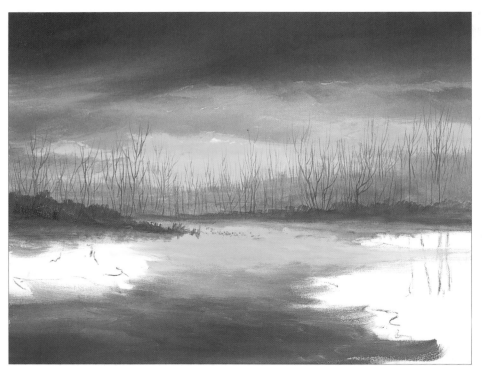

7 Highlight Sky and Underpaint Brush

Mix white with a touch of yellow. Use a no. 4 flat sable or a no. 4 round sable brush to accent the clouds, putting thin slivers of light on the edges of the darker clouds. You can also brighten the sunlight area by drybrushing on additional highlight color. Next, mix white with a touch of purple, Burnt Sienna and Hooker's Green. Use your no. 6 bristle brush and scrub in the background brush. Keep the edges of the background brush area soft.

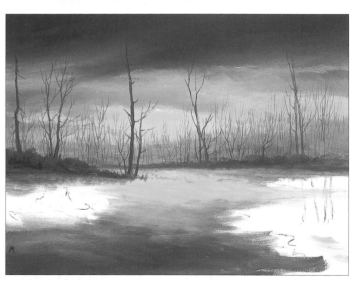

8 Block In Main Trees

Mix purple with a touch of blue and Burnt Sienna until it's creamy. Using a no. 4 flat sable brush, block in the main trunk of each tree. Thin the tree mixture with water and complete the smaller limbs with your no. 4 script liner brush.

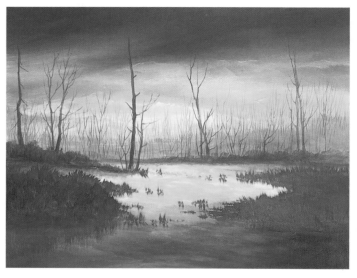

9 Underpaint Middle-Ground and Foreground Grasses

Apply Hooker's Green, purple, Burnt Sienna and white in a sporadic, unorganized manner directly onto the canvas. Take your no. 10 bristle brush and push upward on the wet paint, blending it. Next, drybrush upward to create individual clumps of grass in the water. Add the grass reflection by drybrushing downward from the edges of the grasses into the water. Again, keep the edges soft.

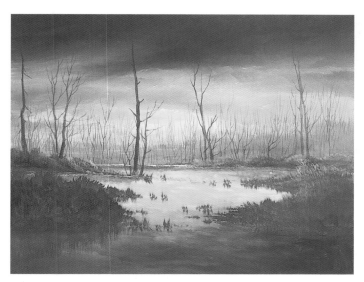

10 Highlight Background and Middle-Ground Grasses

Now add sunlight to the top of the grasses. Mix white with a touch of orange and yellow. This mixture should create a yellowish glow. Take a no. 10 bristle brush and separate the ends of the bristles by applying pressure to a flat surface. Load the brush with just enough paint to cover the tips of the bristles. Dab paint straight onto the canvas, creating a delicate texture. Follow the contours of the underpainting.

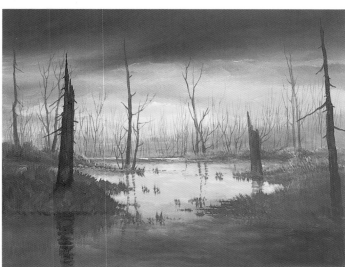

11 Underpaint Large Trees and Reflections

This is a simple step. Mix Burnt Sienna, blue and purple. Use a no. 4 flat sable brush to block in the main body of the large trees. Now thin the mixture slightly and drybrush in the reflections with short, choppy horizontal strokes. Be sure the background shows through in places so the water looks rippled.

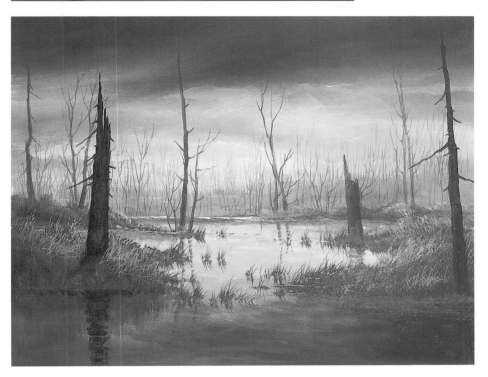

12 Highlight Middle-Ground and Foreground Grasses

You can use two or three different techniques to detail the grasses. The first step is to mix highlight colors: white with a touch of yellow and orange. Divide this mixture and add a touch of green to one half. Use the brush or brushes of your choice to create different textures. The main detail you want to accomplish in this step is to emphasize the taller weeds. Thin your mixtures with water and use a no. 4 script liner brush to make lots of overlapping weeds. The taller weeds will help create a marshlike setting.

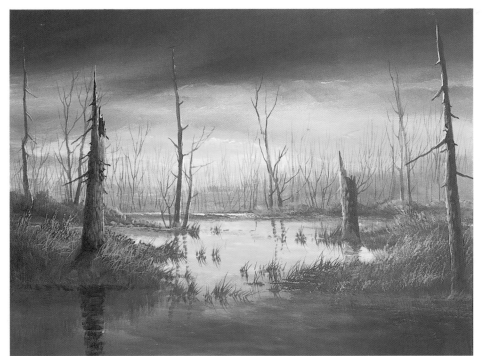

13 Highlight Trees

Highlight all the trees using a mixture of white with a touch of yellow and orange. Use a no. 4 flat sable brush, turning the bristles vertical to the tree trunks and using short, choppy vertical strokes. Create the suggestion of bark and highlights. Mix the reflected highlights using white with a touch of purple and blue. Apply this mixture to the dark side using the same brush technique. Be sure to leave some of the dark background showing through to create depth and texture in the bark.

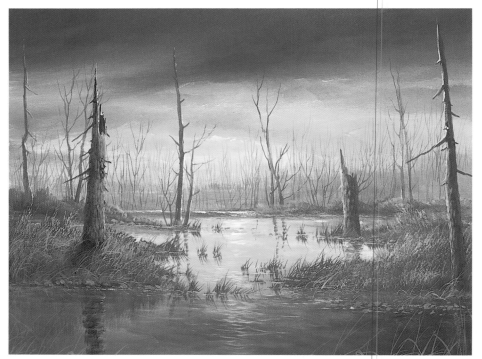

14 Add Final Highlights and Details of Landscape

First, add the rocks on the shoreline. Mix white with a touch of orange. Use a no. 4 flat sable brush and gently drybrush the small rocks along the shoreline. Do not make them too bright. Add more white to this mixture and paint thin horizontal ripples on the water to accent the sun shining on the water. Use the same technique along the shoreline and the bases of the clumps of grass. Thin the mixture to an inklike consistency with water and use a no. 4 script liner brush to paint in taller weeds around the tree trunks and in the right foreground corner. This will act as an eye stopper.

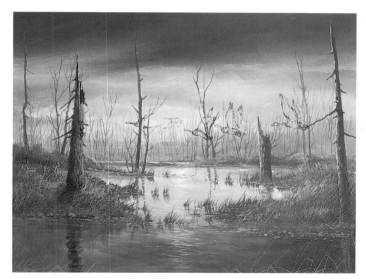

15 Sketch Geese

Do not let this step intimidate you. Take a piece of soft vine charcoal and scrape the end until it forms a point. (You can use a soft vine charcoal pencil if you prefer.) Now sketch the geese as accurately as you can. Remember: If you make a mistake don't panic. You can use a damp paper towel to wipe off mistakes.

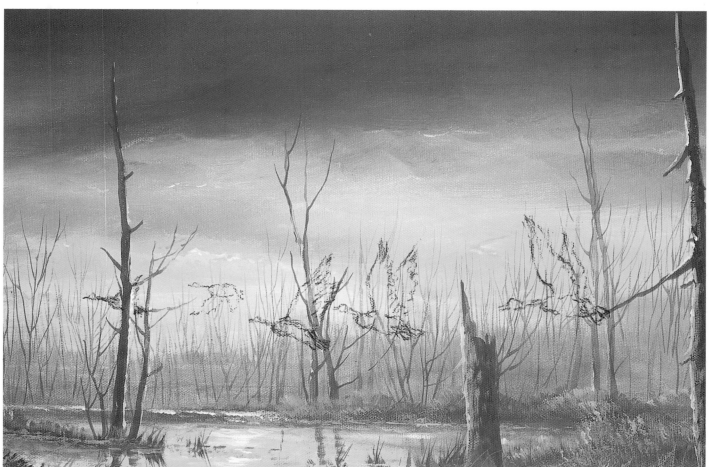

You may want to use a photo as a reference when sketching in your geese.

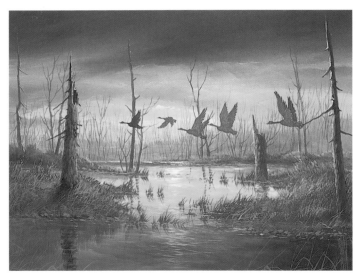

16 Underpaint Geese

Mix white with a touch of purple, Burnt Sienna and blue. Add a small amount of water and mix until it becomes creamy. Block in each goose using a no. 4 round sable brush. You can vary the intensity of this color by adding more blue and Burnt Sienna. You may want to make the lead goose, as well as the back wings of the other geese, a little darker.

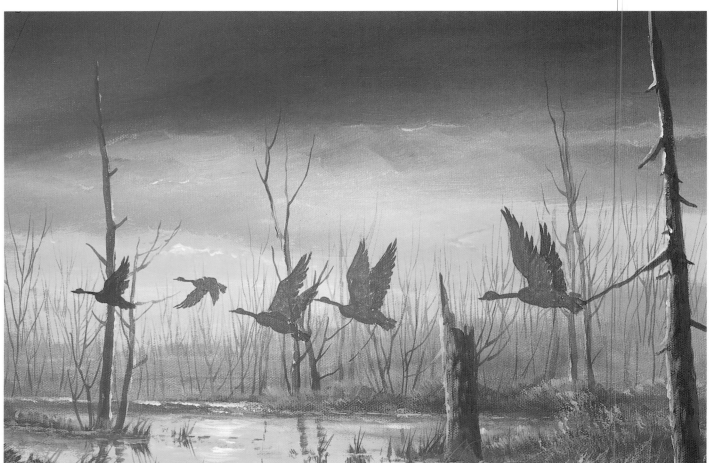

17 Wipe Off Sketch

Before you proceed with your painting, make sure to wipe off any excess charcoal with a damp paper towel.

Close-up of underpainted geese

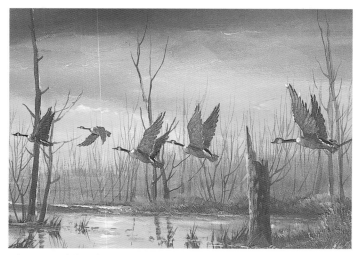

Close-up of detailed geese

18 Detail Geese

The old saying "A picture paints a thousand words" is appropriate for this final step. Study the finished geese. Notice the dark, light and middle-tone values. Use a no. 4 round sable brush for the details. Mix the appropriate color and value, and make sure the paint is creamy. Mix Burnt Sienna and blue for the very dark areas, add a touch of white to the mixture for the middle-tone values, and mix white with a touch of yellow for the highlights. Use pure white for the breast and tail feathers. Use light feathery strokes, much like a drybrush stroke, to apply the colors.

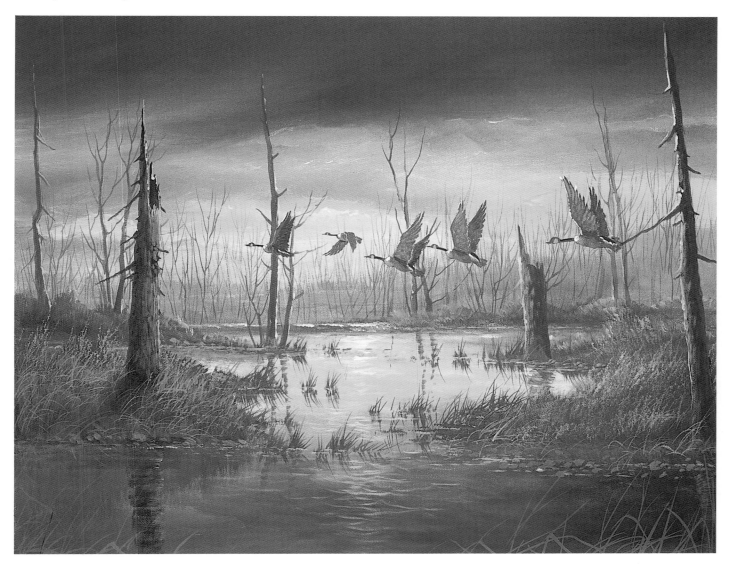

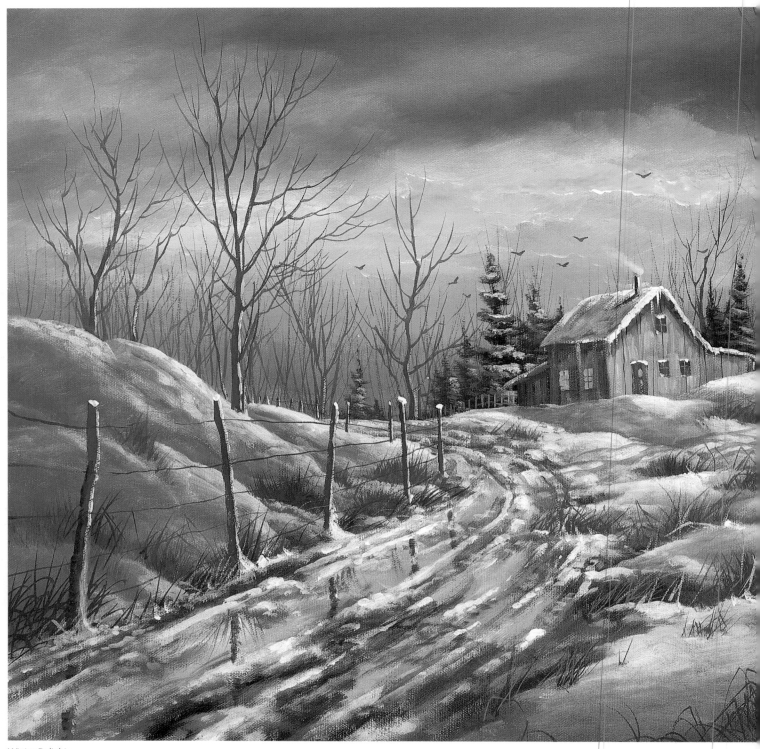

Winter Delight
16" x 20" (40.6cm x 50.8cm)

Winter Delight

I love winter. I know many people do not like the cold, but from a learning perspective, painting snow will help you in all other aspects of painting techniques. The main purpose for this painting is to demonstrate how to blend snow and create soft edges. This is one of the most important techniques you will use in many of your other paintings. In addition, this painting will teach you how to take a very cold day and create a pleasantly warm atmosphere.

1 Create Charcoal Sketch

Using your soft vine charcoal simply sketch in the basic contour of the landscape and the cabin.

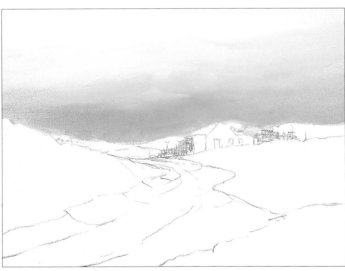

2 Underpaint Sky and Horizon

Lightly wet the entire sky with your haké brush and then gesso over the entire sky. Using pure orange, streak horizontally across the base of the sky, blending upward using loose strokes. Be sure not to overblend.

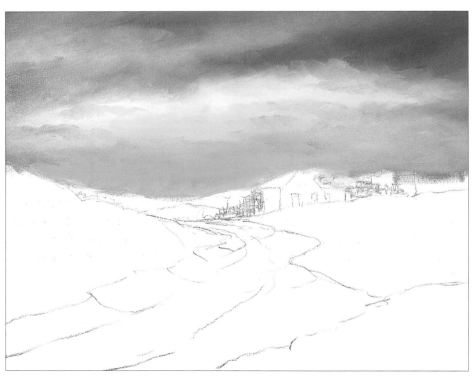

3 Block In Dark Cloud Formations

Now use purple with a touch of blue and Cadmium Red Light. With your no. 10 bristle brush scumble these colors across the sky while the gesso is still wet. Keep the sky fairly rough to create the suggestion of cloud formations. It is very important that all of the edges of the clouds are soft.

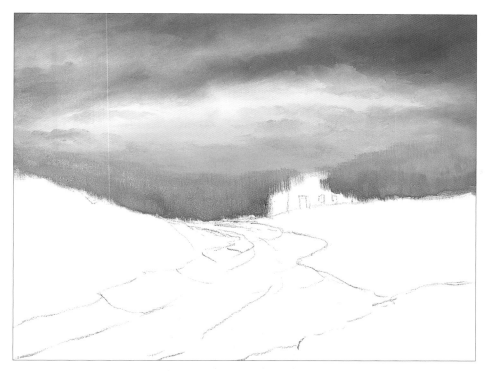

4 Block In Distant Horizon

Mix white with a touch of purple, a touch of blue and a slight touch of Burnt Sienna. Use a no. 10 bristle brush to smudge in the distant background. Try to suggest distant hills or trees. Be sure the edges are softly blended into the sky so there are no hard lines.

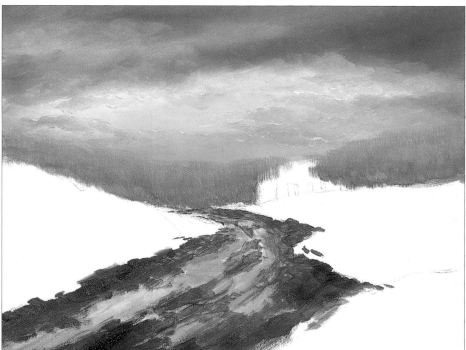

5 Block In Road and Accent Clouds

First mix white and orange and, with a no. 6 bristle brush, smudge in pockets of color throughout the road. Then mix Burnt Sienna with a touch of purple and smudge in the muddy part of the road. Use short, choppy strokes, loose and free. Accent the clouds with a mixture of yellow and white, using a no. 4 round sable brush.

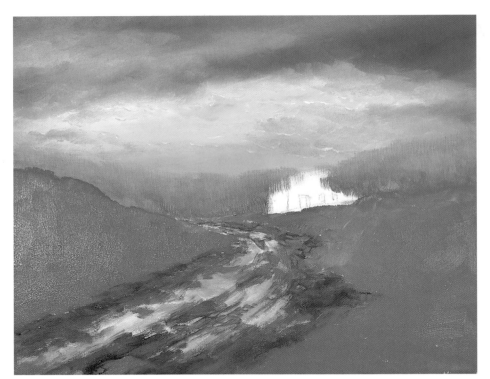

6 Underpaint Snow

Mix a fairly large amount of white, blue, a touch of Burnt Sienna and a touch of purple. This should be a fairly dark purplish gray. Completely paint both sides of the road using your no. 10 bristle brush. Cover the canvas almost solid. Then smudge small patches of this color on and around the edges of the road.

7 Paint Background Trees

In this step you will paint the background trees using a very thin mixture of water, white, blue, Burnt Sienna and purple. This color should be just slightly darker than the background hills. In fact you can use the color you mixed for the underpainting of the snow in the previous step. With this inklike mixture, load your no. 4 script liner brush and roll it to a point. Then starting at the base of each tree, pull upward with a light choppy motion, gradually decreasing pressure until you have created the limbs. The strokes should gradually taper from thick to thin. (I recommend that you practice this stroke on scrap canvas before you begin the painting.)

8 Block In Background Cedars

Mix Hooker's Green, a touch of Burnt Sienna, purple and a touch of white to change the value. Load a no. 6 bristle brush with this mixture and dab it straight onto the canvas. Use different areas of the brush—the corner, side and tip—to create different thick or thin areas of the trees. Be sure each tree is slightly different: It is very easy to get into a bad habit of making each tree alike.

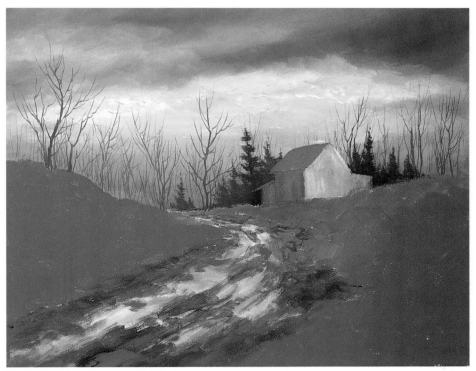

9 Block In the Cabin

Using a no. 4 flat sable brush block in the roof of the cabin with the dark purple-gray color used for underpainting snow. Then mix a little Burnt Sienna and white with the same color and block in the shadowed side of the cabin. Now mix white with a touch of Burnt Sienna and orange to underpaint the light side of the cabin. Square up the cabin, making sure all the canvas around it is covered.

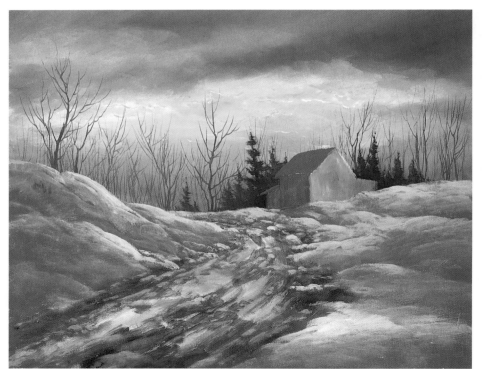

10 Highlight the Snow

Mix a fairly large amount of white with a very tiny touch of yellow. You only want to tint the white slightly. Now take the no. 6 bristle brush and load it evenly across the tip. The mixture should be creamy. Start at the top and begin drybrushing, using the sides and tip of the brush in a motion that follows the contour of the snow banks. Be sure to leave interesting pockets of light and dark values. Apply various amounts of pressure as you scrub on the highlights. Keep all edges soft, and don't be afraid to put the paint on a little thicker in places. Remember not to cover all of the dark values.

11 Block in Large Trees

Using the no. 4 flat sable and no. 4 script liner brushes, take the dark purple and gray color used for underpainting the snow and add a little Burnt Sienna and a touch of blue to darken it. Add enough water to make it very creamy. Block in the main body of the trees with the no. 4 flat sable, and then add a little more water to the mixture to make it thin enough for the script liner brush. Next add the smaller limbs. This is a good time to put a little of the purplish gray color on the cedar trees and underpaint the snow.

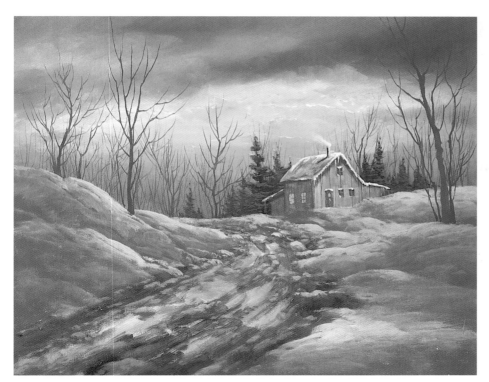

12 Detail the Cabin

This process is done with the no. 4 flat sable brush. Simply take some of the white snow color and drybrush a little snow on the roof, making it thicker around the edges. Block in the front doors and windows with Burnt Sienna, purple and a touch of white. Use this same color for the overhang shadows. Use pure orange and yellow for the light in the windows. Add whatever details you wish—cracks in the wood, icicles, smoke, etc. Just be careful not to make it too busy.

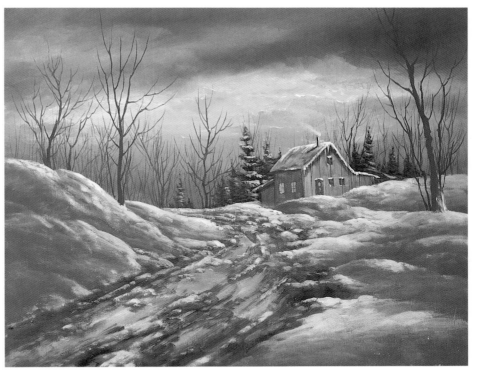

13 Highlight Caps on Snow

Use the same white and yellow highlight mixture as before. The only difference is to put the highlight on thicker to make it brighter. Use the no. 6 bristle brush and/or the no. 4 flat sable and put the highlights on the tops of each of the clumps of snow. Blend out the edges so they fade into the snow underneath. Repeat this step as necessary to make the snow as bright as you wish. Dab a little white on each cedar tree to highlight them as well.

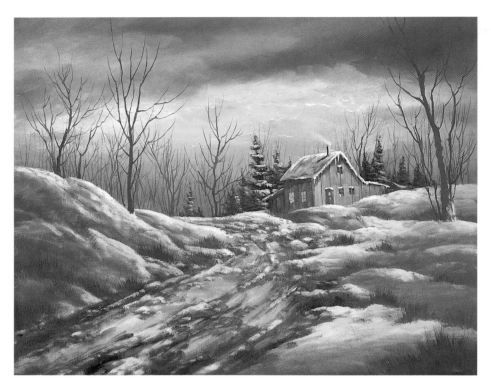

14 Underpaint Grasses and Brush

Make a creamy mixture of white, Burnt Sienna and purple according to the color scheme and value of your painting. Using a no. 6 bristle brush, simply drybrush upward to create grasses and brush. Place the clumps of grass or brush between the piles of snow. Be sure to make different sizes and shapes and overlap them to create good visual flow.

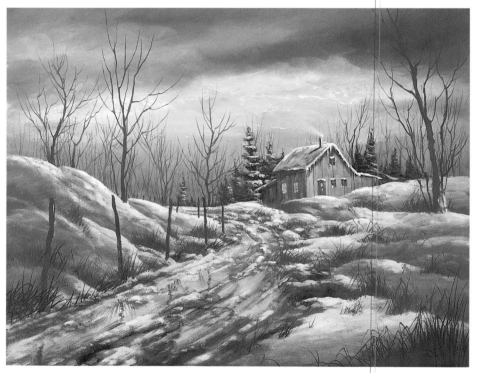

15 Underpaint Fence Posts and Weeds

For the fence posts, mix blue, Burnt Sienna and white to create a gray mixture. Underpaint the fence posts using a no. 4 flat sable brush. If you are not sure where the posts go, use your soft vine charcoal to sketch them in and then paint over them. Now make an inky mixture of Burnt Sienna and purple, and using plenty of water and a no. 4 script liner brush, paint the weeds that come out of the clumps of grass. (**Note**: Scribble in the reflections of the posts with the post color and the script liner brush.)

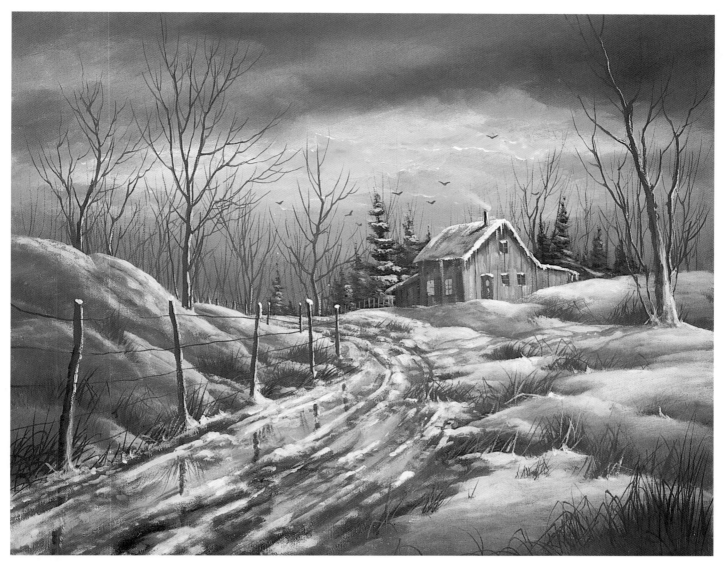

16 Add Final Details and Highlights

This is always an exciting part of the painting! Use your snow-white mixture to highlight the fence posts and trees to create the effect of snow against the bark of the trees or posts. Use a no. 4 round sable brush to drift snow up against the base of each clump of grass, post and tree trunk. Add any other details and highlights you wish—as long as you don't make it look too busy.

Autumn Memories
16" x 20" (40.6cm x 50.8cm)

Autumn Memories

Autumn is one of the most exciting seasons to paint. I chose this particular painting and scene because it reminds me of memories and a special place where I spent time as a child. In addition, from an instructional point of view this painting offers a great opportunity to learn how to paint different arrangements of foliage and different values of warm autumn colors, and it shows a good use of complementary colors. This painting will also help you overcome the challenge of painting leaves.

1 Create Basic Sketch
Use your soft vine charcoal to sketch in the basic components of the landscape.

2 Block In Sky Horizon
Lightly wet your sky with your haké brush and apply a liberal coat of gesso. While the gesso is still wet, add touches of yellow and orange at the base of the sky and blend them upward, using large crisscross strokes, until the color fades out.

3 Block In Top of Sky
While the sky is wet, quickly add purple and a small touch of Burnt Sienna to the top part of the sky. You can use your no. 10 bristle brush or your haké brush to scumble this color down into the yellowish color. Notice the sky is covered with tree leaves, so you do not have to blend as carefully. Leave pockets of dark and light contrasts to create interest.

4 Underpaint Water

Underpaint the water the same way you did the sky. First wet the area and then add the gesso. Start with yellow and orange at the top of the water. Add the purple while the previous colors are wet. Blend quickly and as you come forward add more purple and Hooker's Green to create a deep dark pool in the foreground. Use a no. 10 bristle brush for this process.

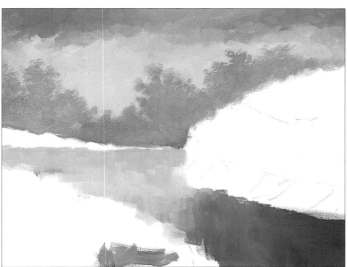

5 Block In Distant Trees

Using your no. 10 bristle brush, mix white with Dioxazine Purple and a touch of Burnt Sienna. Place the brush flat against the canvas and push upward to create interesting shapes. Keep the edges soft and leave unique pockets of negative space.

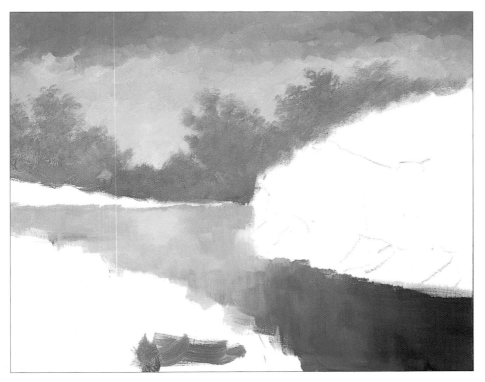

6 Brighten Sky and Water

All you are going to do here is intensify the light in the sky and water. Mix white with a touch of yellow and orange. Take your no. 6 bristle brush and drybrush in more light in the yellow part of the sky and the light part of the water. This gives off a little more glow.

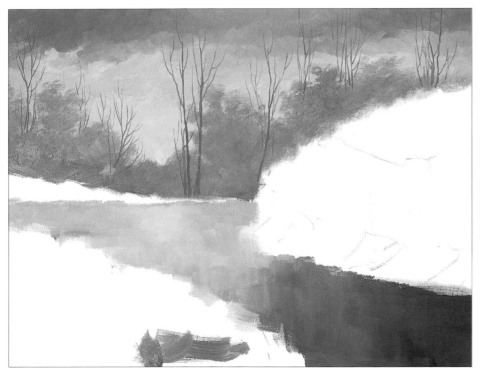

7 Paint In Background Tree Limbs

For this mixture of paint use the same color you used for the background trees, but darken it by adding a touch of Burnt Sienna and a touch of blue. Now add enough water to create an inklike mixture. Load your no. 4 script liner brush, rolling the brush to create a point. Begin at the base of each tree, gradually decreasing pressure as you move up on the tree to create nicely tapered tree trunks. Place several trunks across the background.

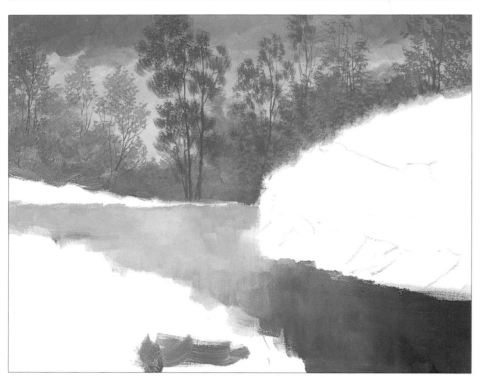

8 Leaf Background Trees

For this step you need two or three mixtures of color. First mix Burnt Sienna and yellow. Next, mix red and purple with yellow. You will add more yellow, red, orange or purple, plus white to these mixed colors to create other colors and values. Using your no. 10 and no. 6 bristle brushes, fluff the ends of the bristles so they become slightly separated. Dab on the colors to create airy leafy patterns. Form varied unique shapes using different mixtures of colors and values so your trees do not look identical.

9 Underpaint Grass and Hillside

Mix Burnt Sienna, yellow and a touch of purple. Place the paint on thick, and while it is still wet, push it upward with your no. 10 bristle brush. Add touches of yellow or Burnt Sienna as you go to create lighter and darker pockets of grass.

10 Underpaint Banks

Block in the banks and shoreline with Burnt Sienna and purple. Use your no. 6 bristle brush to create texture with short, choppy strokes. Cover the canvas completely with this mixture, allowing some areas to appear transparent.

11 Phase I—Highlight Background Trees

You need a mixture of white with a touch of yellow and orange to create a bright sunlight color. Take the very tip of your no. 6 bristle brush and dab the mixture lightly on the edges of each clump of underpainted trees. This creates a three-dimensional leafy pattern.

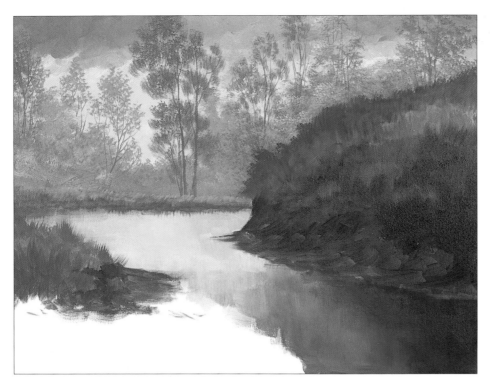

12 Underpaint Foreground Grasses

In this step you will use several colors—yellow, orange, Hooker's Green, Burnt Sienna and purple. Scatter these colors haphazardly on the canvas. While they are still wet, take your no. 10 bristle brush and push upward, blending the colors. This creates a grassy effect. Start at the top of the grassy area and move forward, adding darker values as you move into the foreground.

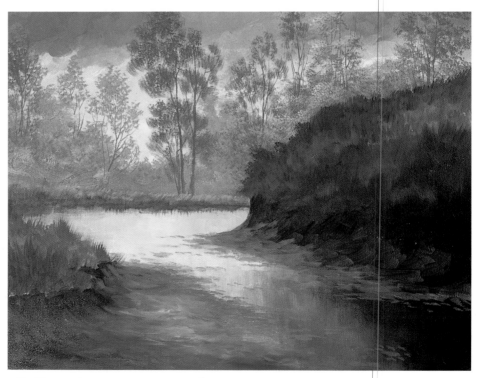

13 Underpaint Foreground

To create a dirt and sand effect, mix white, yellow, orange, Burnt Sienna and a touch of purple. Using your no. 6 bristle brush, begin blending with white and add the other colors as you go. Use short, choppy horizontal strokes to suggest dirt. Scatter some of this color over the water to suggest the debris of leaves.

14 Underpaint Large Tree

In this step use pure Burnt Umber. Thin it slightly with water and mix it until it is creamy. Use your no. 4 flat sable brush and block in the basic shape of the large tree. Switch to the no. 4 script liner brush to add the smaller limbs and branches. Be sure to dilute the paint with water until it becomes more fluid when using the script liner brush.

15 Phase II—Highlight Background Trees

Finalize the highlights of the background trees by using the same procedure as in step 11. You may want to add a touch more yellow, orange or even red to create highlights that are more vivid. Use a no. 6 bristle brush to dab on these highlights.

16 Highlight Middle-Ground Grass

In this step use pure color to brighten the grass and create a sunlight effect. You can use a no. 10 or no. 6 bristle brush to drybrush, dab or scumble on highlights. Mix yellow, orange, white and touches of red in different amounts to create different colors of light. Experiment with different angles and different pressures on the brush to create a variety of sunlight effects.

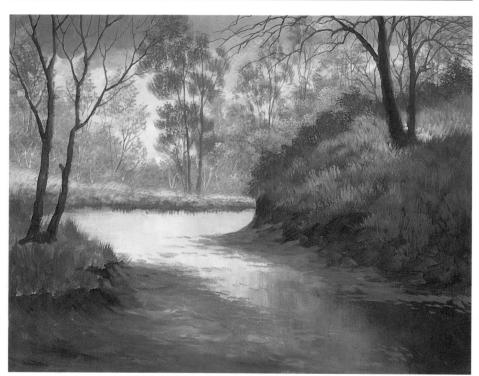

17 Block In Large Foreground Trees and Light Background Trees

Mix white with a touch of Burnt Sienna and blue to create a light gray. Thin this mixture and use your script liner brush to paint the light-colored limbs in the background. Then use pure Burnt Umber and your no. 4 flat sable brush to block in the left foreground tree. Finish with the no. 4 script liner brush, using the pure Burnt Umber.

18 Highlight Banks and Rocks

Mix white and orange as the sunshine color. Take your no. 4 flat sable brush and drybrush little humps of light along the bank and shoreline. Apply them to both sides of the water. Do not put the paint on too thick or it will be too bright. Merely suggest the rocks. Drybrush small amounts of this color on the edge of the bank. Make sure you leave all strokes with soft edges.

19 Underpaint Foreground Grass and Rocks

Take your no. 10 bristle brush and scrub up some grass around the large tree on the left to create a shadow, using a mixture of Hooker's Green and purple for the shadow color. Then mix yellow and orange or yellow and Burnt Sienna, or even add a little green, and pull up lighter-colored grass to create the effects of sunlight. Next, using the no. 4 flat sable brush, mix purple, Burnt Sienna and a touch of blue. Dab this color onto the foreground rocks.

20 Highlight Red Tree and Add Reflection

Take your no. 6 bristle brush and spread the bristles out on the end by applying pressure to a hard surface. Use pure Cadmium Red Light with a touch of orange and dab highlights on the large red tree in the background. Next, weaken the value by adding a small amount of white and smudge in the reflection using a horizontal stroke. Do not make it solid, but instead allow some of the background water to show through. Repeat the same process with the tree trunks, but use the trunk color of Burnt Umber with a touch of white to achieve the same effect on the reflection.

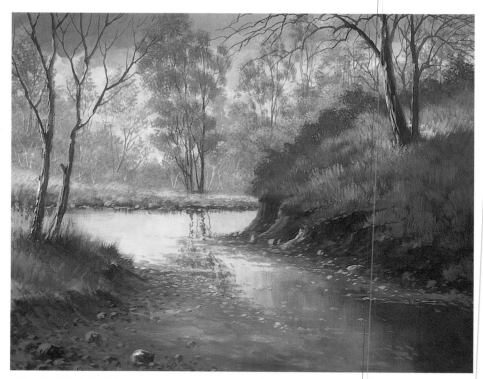

21 Highlight Foreground Rocks and Tree Trunk

Mix white with a touch of orange and yellow to create a sunshine color. Then take your no. 4 flat sable brush and use short, choppy vertical strokes to create the bark on the trees. Be sure to let some of the background show through to give more of a textured look. Next, using the same color, load a small amount of paint on your brush and drybrush soft highlights on the top of the rocks and pebbles. You can darken or lighten the value by adding a touch of brown or white, depending on where the rock is located.

22 Add Foreground Tree Leaves

This step is fairly time-consuming but not difficult. Mix Burnt Sienna and purple until it becomes creamy. Using a no. 4 flat sable brush make small overlapping comma strokes beginning at the top of the trees. Do not make the leaves solid: You want to create the effect that some leaves have fallen off.

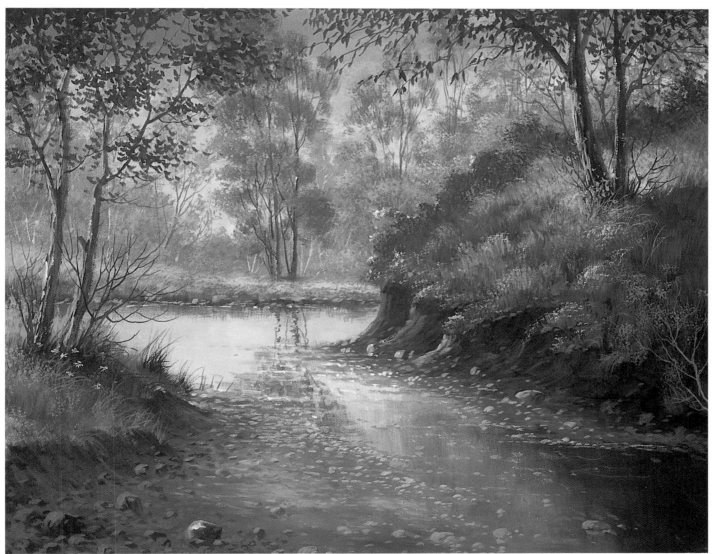

23 Add Final Details and Highlights

Adding highlights to flowers, weeds, bushes and water can be accomplished with a no. 4 script liner brush or your no. 4 round sable. Whatever colors you choose for these final details, make sure the mixture is fluid. Lighten the value by adding white, or darken it by adding pure color.

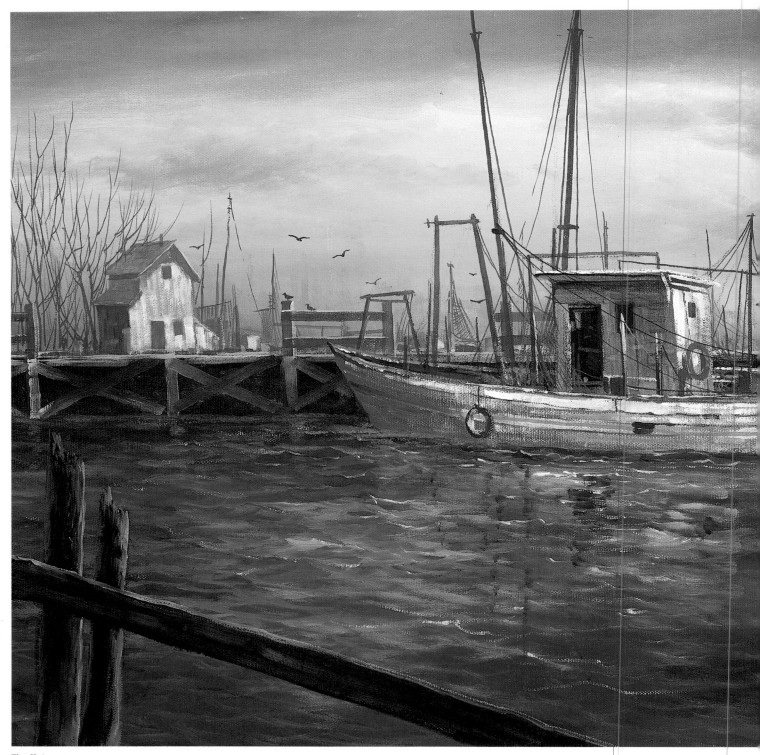

The Shrimper
16" x 20" (40.6cm x 50.8cm)

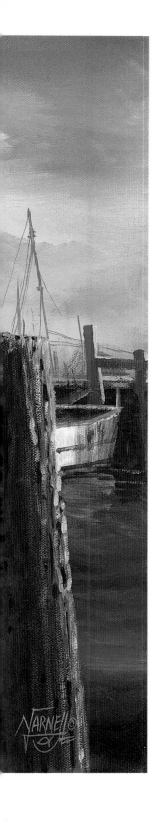

The Shrimper

In my many travels across the country, one of the most interesting individual subjects I have found to paint is old shrimp boats. They are a dying breed, but what a wide array of artistic forms they possess. I chose this painting not because of any special colors, depth, values or atmosphere, but because of the unique design of the boat and surrounding objects, such as the post, rigging, dock and water. The painting helps you understand the techniques used to create old weathered wood, which is an important study for buildings and other man-made objects.

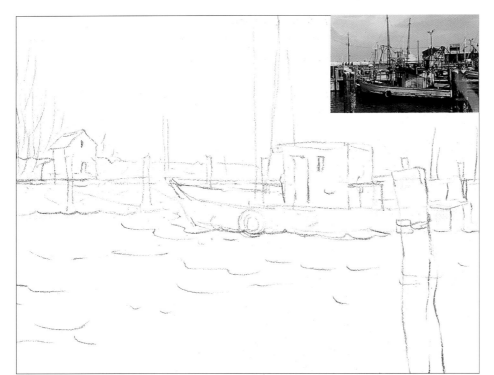

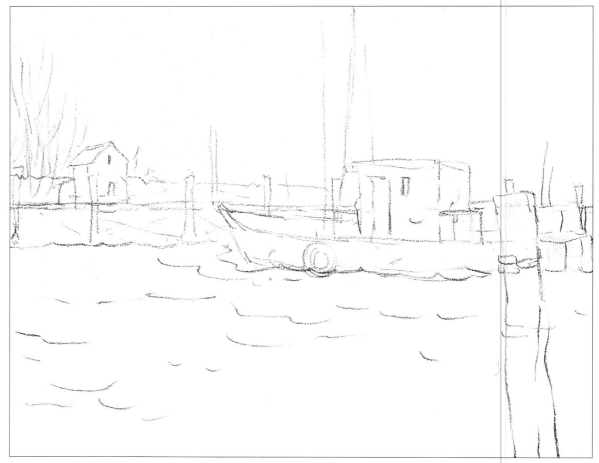

1 Create Rough Sketch

The first thing you need to do is make a rough charcoal sketch of the main subjects in the painting. Sometimes it's helpful to use a photograph as a basis for your sketch.

Close-up of finished sketch

2 Underpaint Horizon

Wet the sky with your haké brush and cover the area with a liberal coat of gesso. Streak pure orange across the horizon, blending upward until it disappears into the white. Use long *X* strokes. Work quickly and then move on to the next step.

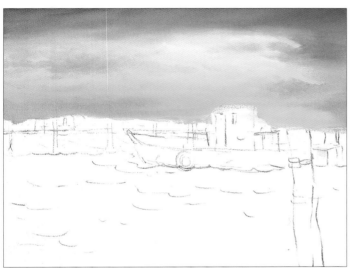

3 Underpaint Top of Sky

While the background is still wet, take purple with a touch of orange and streak the color across the top of the sky. Use random horizontal blending strokes. Leave pockets of light and dark areas to create the suggestion of movement in the cloud formations.

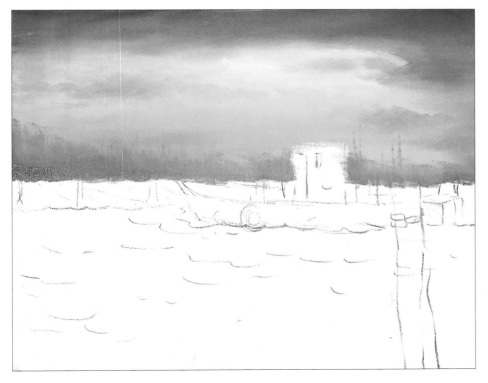

4 Underpaint Background

For this step you want to create a soft hazy purple mist. Mix white with purple using a no. 10 bristle brush and scrub in a soft muted background. Be sure the edges next to the sky feather out very softly.

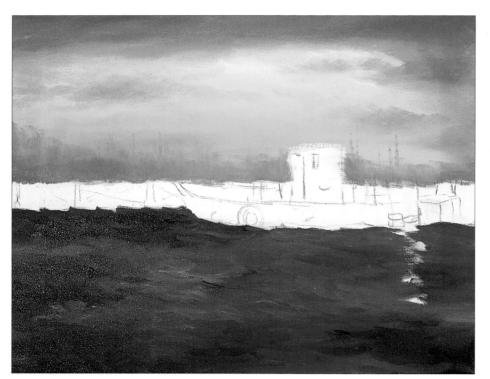

5 Underpaint Water

Use a no. 10 bristle brush and mix the following colors on the canvas to create a dark underpainting. Apply blue, purple, green, touches of Burnt Sienna and a little white. To help blend and change the values, use a comma stroke by turning your no. 10 to its side. Get in a rhythm of making short, choppy, overlapping comma strokes until all of the water is completed.

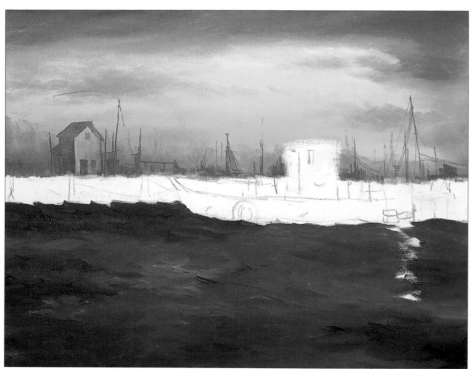

6 Block In Background Subjects

Here you want to create the suggestion of distant objects, such as a boat's mast, posts, nets, rigging and piers. Mix white with purple and a touch of burnt sienna. Use your two smaller sable brushes and drybrush in each object so that they overlap each other and possess good negative space. Do not make it too busy, but put in enough objects to make it interesting. Also remember not to make it too dark.

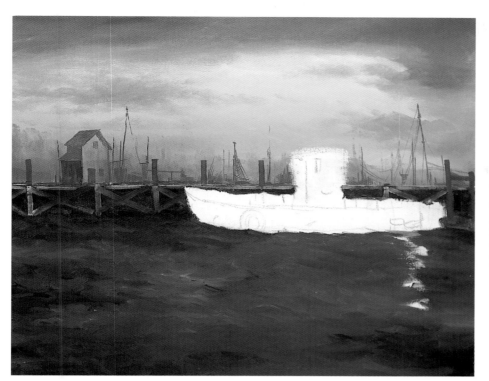

7 Underpaint Pier

Mix a dark shadow color of blue, Burnt Sienna and purple. Blend it until it becomes creamy. Use a no. 4 flat sable brush and underpaint the dark shadows underneath the pier. Blend the shadows into the water. Now add white to the shadow color to lighten the value. Drybrush in the posts and supports in, around and under the pier. Do not make these objects too light in color: Remember they are just underpainting.

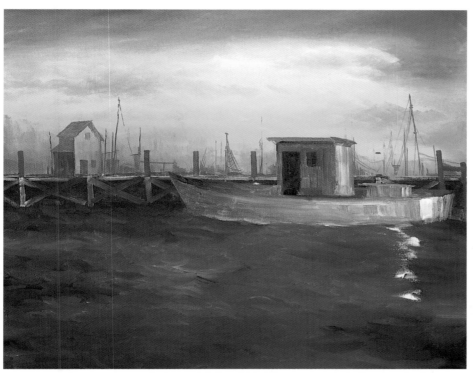

8 Underpaint Boat

Mix white with a touch of blue, purple and a little Burnt Sienna to gray it. Then use your no. 6 bristle brush or your no. 4 flat sable. Using a drybrush stroke block in the intermediate values of the boat. Keep your strokes crude to suggest weathered wood. Now darken the mixture with blue and Burnt Sienna. Block in the intermediate values of the boat: Again, keep your strokes crude to suggest weathered wood. Now darken the mixture with blue and Burnt Sienna and block in the door, window and darker areas of the boat. Use pure white with a touch of gray for the end of the boat.

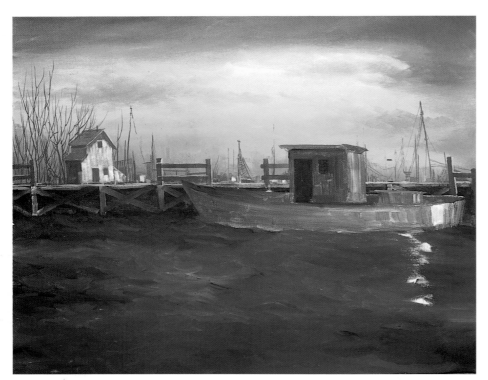

9 Detail Middle-Ground and Background Objects

This is a fun step. Take the dark mixture you used when blocking in the boat and add white to lighten it. Add water to thin the mixture until it becomes inklike. Use your no. 4 script liner brush and paint in the distant trees and any other fine-line details that you notice. Switch to the no. 4 flat sable brush and paint in the other miscellaneous details, such as the railings on the pier and the white front of the harbormaster house. You can even pick up touches of red, yellow or green and add suggestions of nautical objects sitting around on the pier. These items will add great interest to the painting.

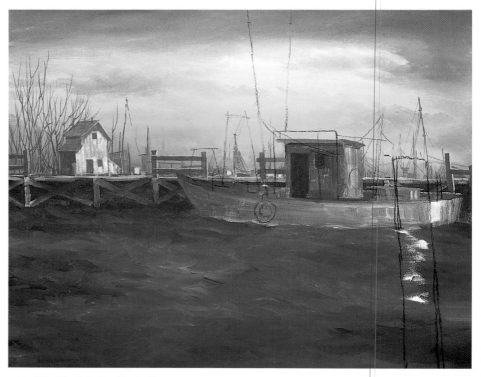

10 Sketch In Details

Take your soft vine charcoal and make rough outline sketches of the middle-ground and foreground objects.

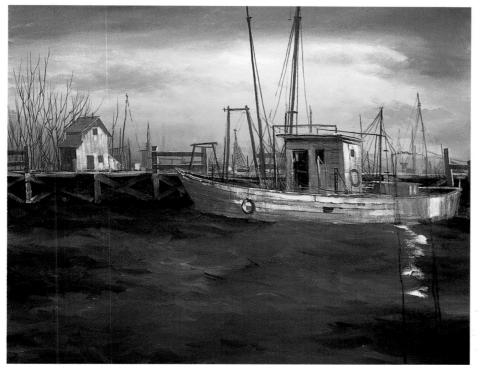

11 Detail Boat

This is not a complicated step, but it can be time-consuming, depending on how meticulous you are with detail. First, create an inky mixture of purple, blue, Burnt Sienna and a touch of white. Take your script liner brush and paint in all of the fine-line details. If you are unsure of your steadiness with the script liner brush for the thin lines, you may want to practice on a scrap canvas. Other tricks you may try to paint straight lines are to lay your canvas down on a flat surface, to turn the canvas upside down, or to use an artist maul stick to steady your hand. After the fine-line detail work, use a no. 4 flat sable and dry-brush pure white over the side of the boat. Make sure you allow the background to show through to create a weathered look. Now add all the other details you would see, such as life buoys, cracks in the wood, red trim on a boat, nets, wires and ropes. If you make a mistake, before it dries wet a paper towel and wipe the mistake away.

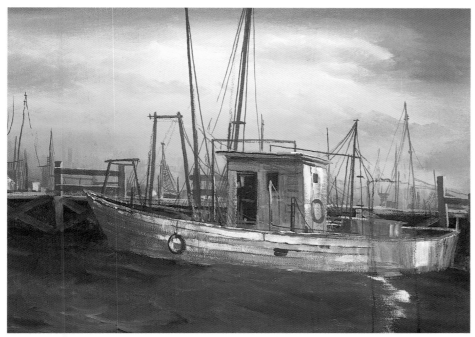

Close-up of boat

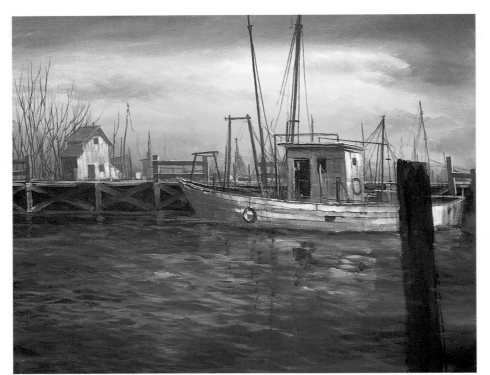

12 Underpaint Pier Post and Highlight Water

First highlight the water. Mix blue with white, yellow with white, orange with white, and green with white, and have a pure white. Use a no. 4 flat sable or a no. 6 bristle brush. Study your painting to see where highlights should be placed. You will use short overlapping comma strokes with a no. 6 bristle brush to highlight the water and create reflections at the same time. Make sure the dark background of the water shows through to create depth. Repeat the highlights until they are as bright as you want them to be. Next, mix Burnt Sienna, blue and purple to underpaint the foreground pier post.

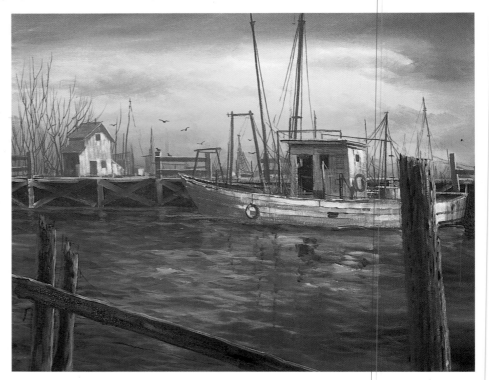

13 Add Miscellaneous Details

After you finish painting the water, block in the broken boards like you did with the pier post. Use a mixture of white and orange for the sunshine color. Then take a no. 4 flat sable brush turned sideways and use short, choppy vertical strokes similar to the strokes used when barking a tree. This type of stroke creates the weathered texture that is necessary in this painting. Next, mix blue, purple and white for the reflected highlights and drybrush this on the dark side of the posts. This reflected light helps create the roundness of each post.

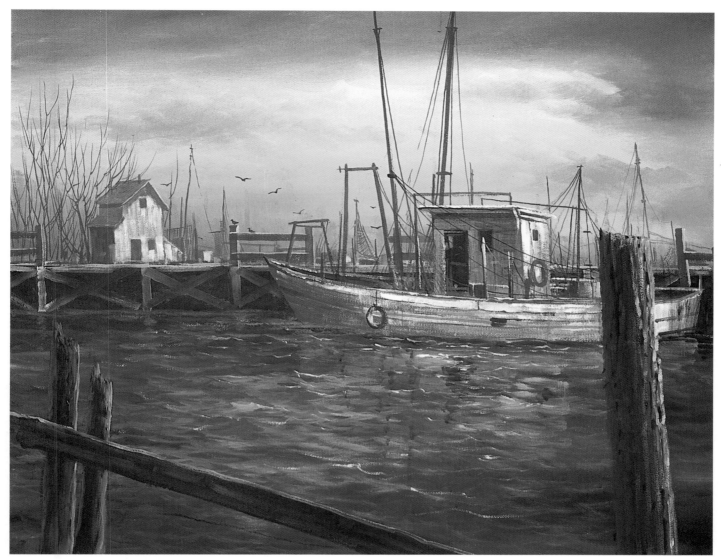

14 Add Final Highlights

Basically, we are finished with the painting. However, at times it is fun to add a little more snap to the highlights. Here I used pure white and drybrushed some thin highlights on the top of the water to make a sparkle. Search the painting and add any final touches that seem appropriate. Just remember my motto as you do each painting: "Don't piddle, play, or putter." These are the three P's of painting. Keep painting and stay inspired.

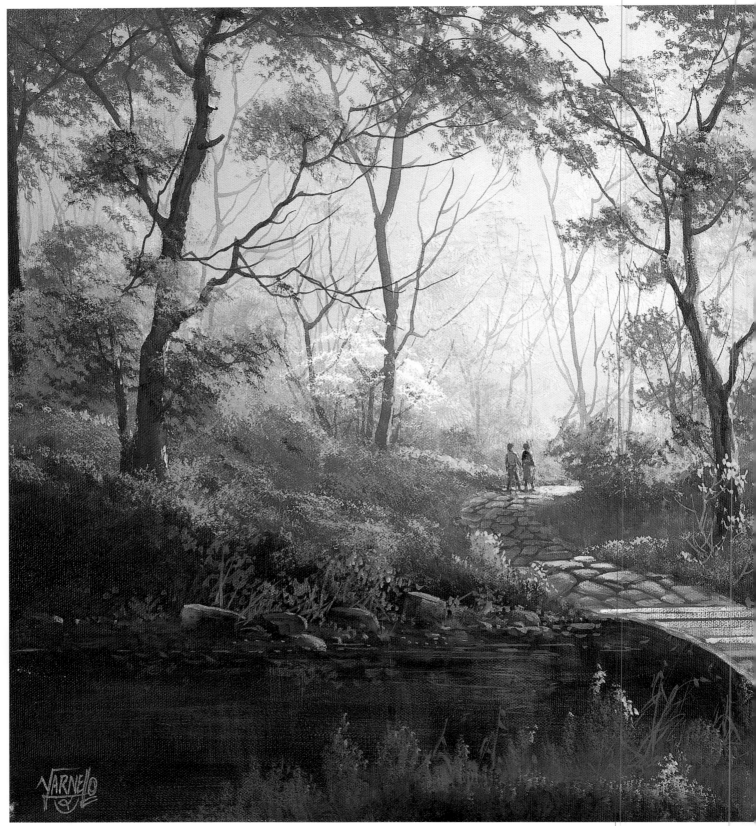

The Pathway
16" x 20" (40.6cm x 50.8cm)

The Pathway

This is Woodward Park, where I spent many childhood hours playing. Every spring it bursts into an array of different colors. I chose this painting to show how to use overlapping values of different colors of green to create a forest setting and how to accent painting with pure complementary colors. This exciting painting takes a little more time because of all the leaf work, but the result is phenomenal.

1 Create Rough Sketch

Make a rough sketch of the main components of the landscape. There is no need to sketch every single tree: You may change their shape or location during the painting.

2 Underpaint Sky

Begin by lightly wetting the sky area with your haké brush. Apply a liberal coat of gesso. While the gesso is still wet, apply a very small amount of blue and purple. You want the sky to be very soft and pastel. Be careful not to apply excess color. Use large X strokes to blend a nearly smooth sky with a few lighter and darker areas.

3 Underpaint Background Trees

Mix white with a touch of purple using your no. 10 bristle brush and dab in the background trees. As you dab leave texture to create a more leaflike effect. You can see I added a little yellow and a touch of orange to the mixture and dabbed on some yellowish colored background trees farther up into the sky area. (**Note**: To get your brush to work better for this step and the other leaf steps to follow, take your no. 10 brush and apply pressure on a hard surface to separate the bristles into a fan shape. This process will help create notable foliage on a tree.)

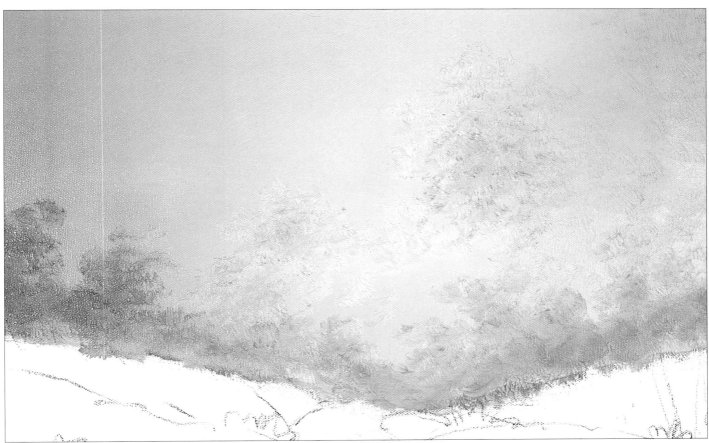

Close-up of background trees

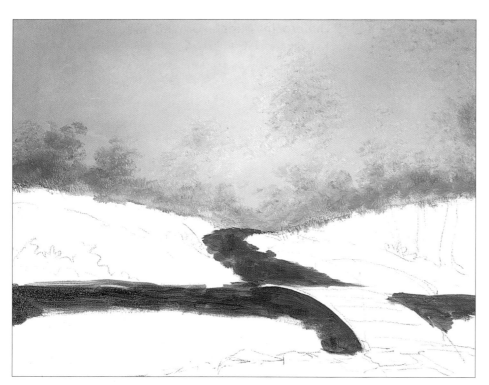

4 Underpaint Pathway and Shoreline

Take your no. 6 bristle brush and scrub in the pathway, shoreline and shadow under the bridge. Use a mixture of purple and a touch of Burnt Sienna to cover the canvas.

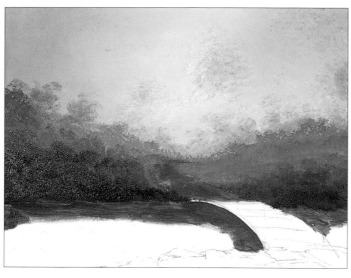

5 Underpaint Middle-Background Grasses and Brush

This is not a difficult step, but be sure you have a value change from back to front. Notice the lighter bushes in the back gradually get darker as they come forward. Mix white with a touch of purple and Hooker's Green. Vary the mixture to create different shades and values of graying green. Then take your no. 10 bristle brush and begin dabbing and scumbling in the different shapes.

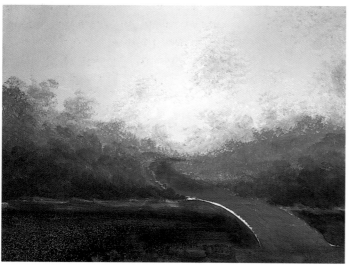

6 Underpaint Water

Mix a very dark mixture of purple, Hooker's Green and a touch of Burnt Sienna. Scrub in the water area with your no. 10 bristle brush. Then add a bit more purple and a touch of white to your mixture and block in the bridge and foreground.

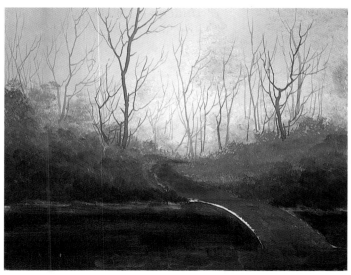

7 Underpaint Middle-Ground and Background Tree Trunks

In this step, use the same mixture you used for the bridge and foreground. Add touches of white for the more distant trees; add less white for the closer trees. Once you mix the proper values, thin the mixture to an inklike consistency. Use a no. 4 script liner brush and load it with this mixture. Roll the script liner brush until it forms a point. Begin with the back trees, starting at the base of each tree. Lighten the pressure as you move upward creating a nicely tapered tree. Construct a variety of tree shapes and sizes.

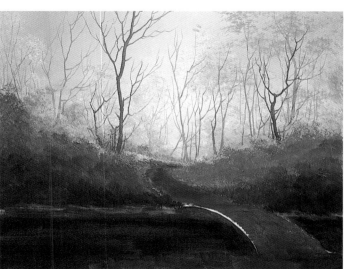

8 Add Light-Colored Foliage

Use a no. 10 bristle brush to add light-colored foliage to create a sunlit glow. Mix yellow with a touch of orange and white. Be sure to separate the tip of the bristles to create better texture to your leaves. Load your brush and dab on areas of foliage throughout the background. Remember this is springtime, so do not make the coverage solid. Also, vary your colors to create variety.

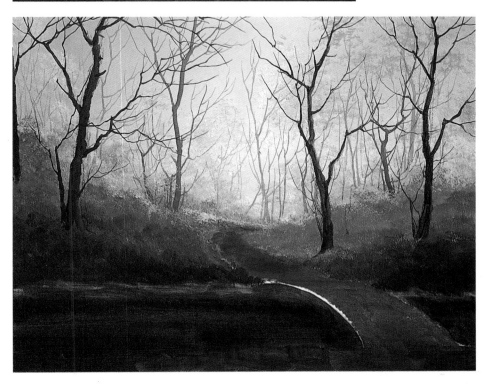

9 Block In Foreground Trees

Block in the foreground trees by mixing Burnt Umber with a touch of purple. Add water and mix until the paint becomes creamy. Use a no. 4 flat sable brush to block in the main shape of each tree. After blocking in the shapes, thin the mixture to an inklike consistency. Use a no. 4 script liner brush to finish out the smaller tree limbs.

10 Add Middle-Ground Foliage Highlights

The next few foliage steps will be similar in nature as you change colors and values. In this step, you will work with the middle-ground foliage. Using a no. 10 bristle brush, separate the bristles and begin dabbing on different colors of highlights creating different shapes of bushes and ground cover. Experiment with different pressures on the brush and canvas and different thicknesses of paint. You will be surprised what minor adjustments will do in creating different effects. (**Note:** Even the no. 6 bristle brush works in this step.)

11 Highlight Path and Bridge

Begin the pathway and bridge by locating the stones and wood planks. First mix white with a touch of orange. Use a no. 4 flat sable brush and paint in the sunlit stones, leaving a tiny space between each one. Next drybrush the planks of the bridge with the same mixture. Thin the mixture to a thin wash and drybrush the stones in the shadow of the path. The thin wash will allow the dark background to show through and creates shadows.

12 Leaf Large Trees

Use your no. 10 bristle brush and mix Hooker's Green and purple. The texture must be creamy. Blot in the dark areas of the foliage on the trees and ground. These are the shadowed areas and will require very little, if any, highlights. Again, let plenty of background show through to create a springlike effect. If it becomes a solid-leafed tree, dab in sky color to open some space.

13 Highlight Rocks and Add Reflections

In this step you want to suggest rocks along the shoreline and dry-brush in some reflections. The foreground is mostly inside a shadow, so be careful not to overhighlight this area. You will accent sporadically here and there. Mix white, orange and a touch of Burnt Umber. Use a no. 4 flat sable brush and drybrush the rocks along the shoreline. Next mix a small amount of Hooker's Green and possibly a touch of yellow and drybrush a few reflections in the water. All of your strokes should be soft and subtle.

14 Add Final Details In Brush and Grass

This step is similar to the other foliage steps. You may use a variety of brushes, colors, values and thicknesses of paint. The main idea to remember is to make your mixtures creamy before applying the foliage texture. Thin your paints with water before using a no. 4 script liner brush when painting weeds, tree limbs, etc. (**Note:** If you want your colors to gleam, add a touch of gesso. This will cause the paint to become opaque and stand out more.) Finish the foreground stones on the path with a wash of white and a touch of orange.

15 Add Final Overall Highlighting

Mix white with a touch of orange. Use a no. 4 flat or no. 4 round sable brush. Apply a thick sliver of light on the edge of each tree trunk. Drybrush brighter highlights on rocks, the bridge and any other area of the painting you think needs sparkle. You can even use pure colors of yellow, green, orange, red or white for your final touches.

16 Add People

This step is optional. If you have no experience painting people, you may skip this step. The painting will be fine without a human element. However, if you want to try, you can use a quick basic step. First make a rough sketch with charcoal, and block it in with the appropriate underpainting color. For example, a blue shirt or pants will need an underpainting of Ultramarine Blue. Whatever color you choose, you must underpaint with a darker form of the color. Then mix white with your chosen color for the highlight color. I hope you enjoyed this painting. Keep up the good work!

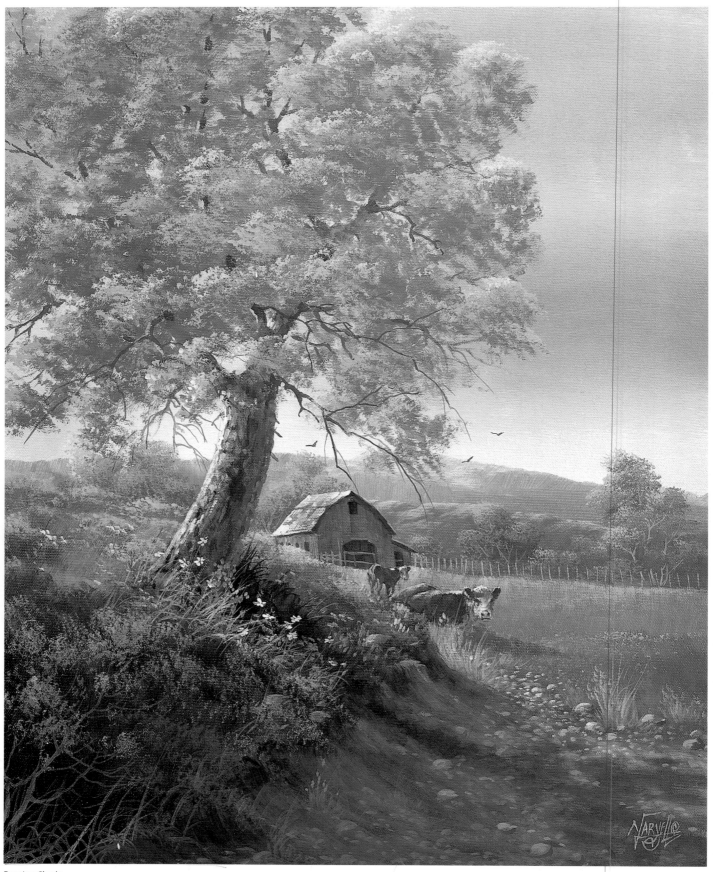

Evening Shade
20" x 16" (50.8cm x 40.6cm)

Evening Shade

Growing up in the Midwest, observing a scene like this was almost an everyday occurrence. During the late spring and early summer, you could always see a mother cow and her baby spending a lazy afternoon in the shade of a large tree. This subject is a great study in a vertical format of subjects in addition to grass, trees, rocks and water. Here the cow, the calf and the red barn in the distance add to your list of subjects. These objects require different brushwork and blending techniques. Do not be intimidated: These new skills are great learning tools and will benefit you in other areas of your learning process.

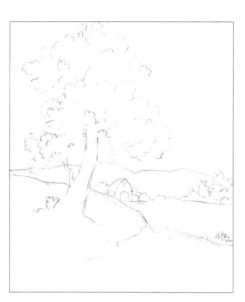

1 Sketch Main Components

Using you soft vine charcoal, sketch in the main components of the landscape.

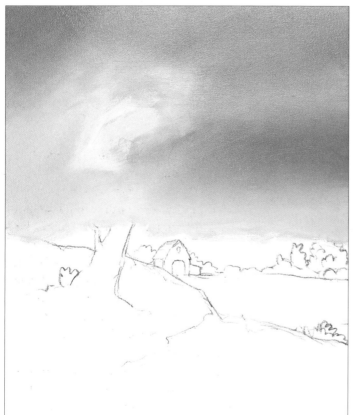

2 Underpaint Sky

For this step you want a clear, clean blue sky. First wet the sky with water using your haké brush. Then apply a liberal coat of gesso. While the gesso is still wet, use pure Ultramarine Blue. Use large X strokes anyplace in the sky. Blend the blue up, down and across the sky area. It is good to have a few darker and lighter areas within your canvas. Keep the color soft.

3 Underpaint Background Mountains

Mix white with a touch of purple, Burnt Sienna and blue. The mixture should be on the purple side. Take your no. 6 bristle brush and scrub in the background mountain. Add a little more purple to the mixture and scrub in the next mountain range. Be sure to keep all of the mountain edges fairly soft.

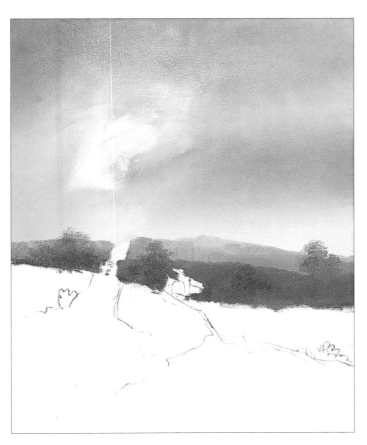

4 Underpaint Background Trees

Add a bit more purple and a touch of Hooker's Green to the mountain color. The green will gray the color slightly. Take a no. 10 bristle brush and fluff out the bristles on the end so they become slightly separated. Then using a light dabbing stroke, block in the shape of the distant trees. Be sure they vary in shape and size, with unique pockets of negative space.

5 Underpaint Middle Ground and Foreground

This is a two-phase step. First mix Hooker's Green with a touch of purple and white. This color should be a greenish gray. Scrub the paint on thick with your no. 10 bristle brush. While the paint is wet, lay the brush flat against the canvas and push upward to create texture. For the second phase, mix Burnt Sienna with a touch of white and purple. Using a no. 6 bristle brush, block in the dirt and bank area using short, choppy horizontal strokes. Add more purple and Burnt Sienna as you move forward.

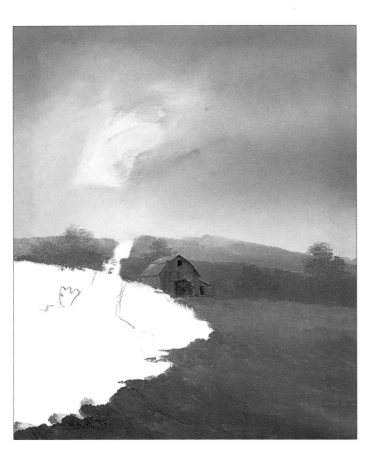

6 Block In Barn

Use a no. 6 bristle brush or no. 4 flat sable brush for this step. Use pure Burnt Sienna for the front, dark side of the barn, and apply the color using a vertical drybrush stroke. Next add a touch of white to the mixture for the lighter side of the barn. For the roof use the same mixture, but add white and blue to create a light gray. You will use Burnt Sienna and purple to block in the doors, windows and overhang shadows.

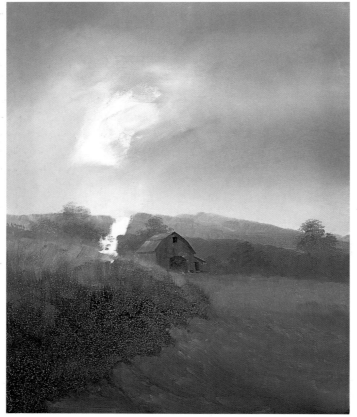

7 Underpaint Foreground Grass

This is a fun step. Use your no. 10 bristle brush and haphazardly scatter Thalo Yellow Green, Cadmium Yellow Light and a touch of Hooker's Green onto the canvas. While the paint is wet, push upward with your no. 10 brush to create the suggestion of grass. As you come forward into the front of the painting, add more Hooker's Green with a touch of purple and Burnt Sienna. This should be a deep, rich forest green color.

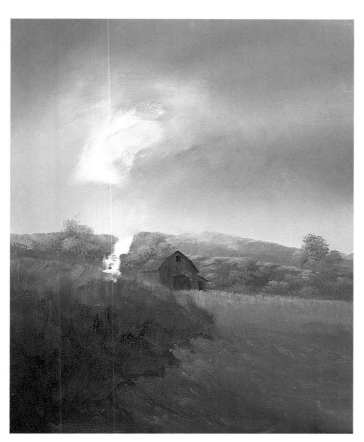

8 Highlight Background

Mix white with a touch of yellow and orange. First smudge a soft highlight on the mountains with your no. 4 flat sable brush. Do not overhighlight or the mountains will stand out too much. Add a touch more yellow to the mixture and use your no. 6 bristle brush to dab on the highlights of the trees. Again, be very careful not to overhighlight: Leave some of the background showing through.

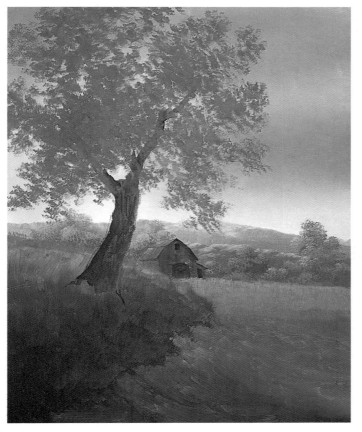

9 Underpaint Large Tree

The first step here is to block in the tree trunk. Use pure Burnt Umber with a touch of purple and a no. 6 bristle brush to block in the main shape of the trunk. Mix Hooker's Green with purple and white to create a greenish gray color. Use a no. 6 bristle brush to scumble on the main body of the leaves. Next, switch to a no. 4 flat sable and use a series of overlapping comma strokes to create a leafy pattern around and through the tree. Be sure some of the background sky shows through.

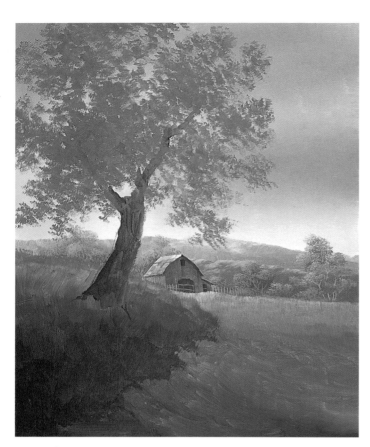

10 Detail Barn and Highlight Background Trees

Use a no. 4 flat sable brush to detail the barn. Use a drybrush stroke to give a weathered wood effect. First use pure red with a touch of white for the lighter side of the barn. Then mix white with a touch of orange for the roof. Use short, choppy strokes to suggest shingles. Now drybrush a touch of red over the darker side of the barn. This will soften the darkness and suggest old wood. For the darker details use purple and Burnt Umber. This mixture should be fluid. Use a no. 4 script liner brush to apply the cracks, shadows, etc. Now mix Thalo Yellow Green and Cadmium Yellow Light with a no. 6 bristle brush and dab on a few brighter highlights on the background trees.

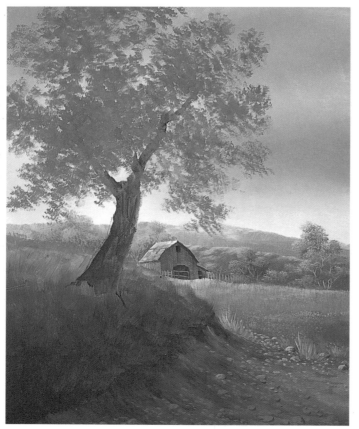

11 Highlight Middle-Foreground Grasses and Rocks

Mix yellow and Thalo Yellow Green with a no. 10 bristle brush and dab on highlights that follow the gentle rolling contour of the land. As you move closer, thin the mixture with water and switch to a no. 4 script liner brush to create individual weeds. Next, mix white with a touch of orange and use a no. 4 flat sable brush to drybrush little humps of highlights to suggest rocks or pebbles. Repeat the highlight color on certain rocks to create more sunlight in the brighter areas.

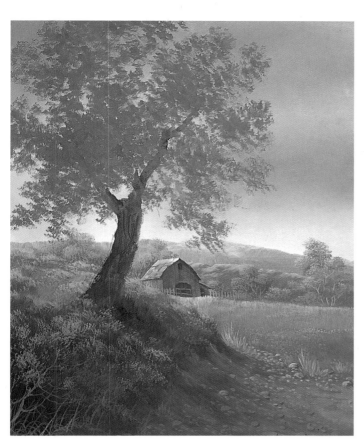

12 Highlight Foreground Hillside

Mix yellow with a touch of Thalo Yellow Green to get a color similar to what was used on the background grass. Use a no. 10 bristle brush and dab highlights on the top of the grass behind, around and in front of the tree. Leave a dark shadow on the right side of the tree. As you move forward add touches of orange. Be sure to use a light airy touch. Do not cover the area entirely but allow the background to appear. Use your no. 4 script brush to paint in the foreground weeds.

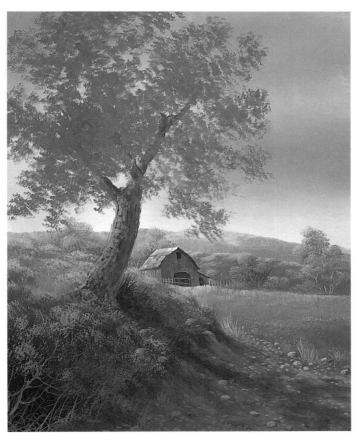

13 Add Bark on Tree and Cast Shadow

Mix a sunshine color of white with a touch of orange and yellow. Use a no. 4 flat sable brush, turning it vertically to the tree trunk. Use short, choppy strokes to suggest bark. Be sure some of the darker bark shows through to add depth of field. Mix white with a touch of purple and blue and use the same technique to create the reflected highlight on the tree. Apply the color to the darker side of the tree. Notice the roundness of the tree when you complete this step. Now mix Burnt Sienna and purple, and using a no. 6 bristle brush, drybrush a shadow onto the ground. Keep the shadow soft—not heavy.

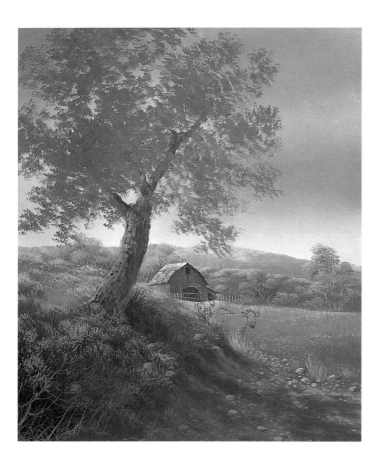

14 Sketch Cow and Calf

Once again the beauty of working with acrylics is that the painting dries quickly, allowing you to use soft vine charcoal to sketch in the cow and calf. (Feel free to use another animal of your choice.) Remember: When using charcoal, all you need to do is take a damp paper towel and wipe off a mistake.

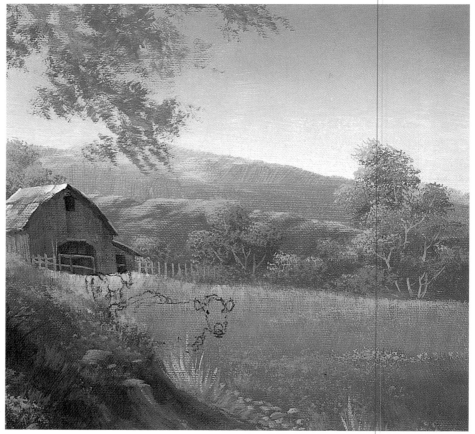

Close-up of cow and calf sketch

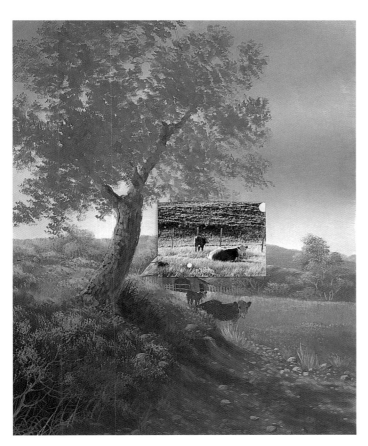

15 Block In Cow and Calf

Once you are satisfied with your sketch, mix Burnt Umber and Burnt Sienna to block in the body of the cow and calf. Use a no. 4 flat sable brush. Add a little blue and white to the mixture to create a gray and then block in the heads. Try to keep the edges of the cows fairly soft—and avoid a hard outline.

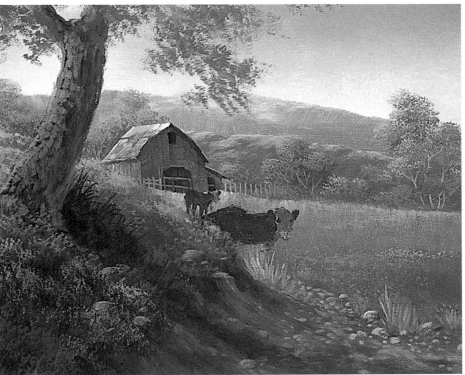

Close-up of cow and calf

16 Detail Cow and Calf

The most important aspect of painting fur is how you apply pressure to your canvas and how much paint and water you use. First mix a highlight color of orange and a touch of white for the darker parts of the cows and mix pure white with a touch of orange for the heads of the cows. Let the mixture dry a bit or the paint will smudge. Your paint mixture should be like soft butter. Once you prepare your two mixtures of paint, use a light drybrush stroke following the contour of the cow's body. Use a no. 4 flat brush for the larger areas and a no. 4 round sable brush for the smaller areas.

17 Highlight Large Tree

Mix white with a touch of Hooker's Green and yellow. Use a no. 10 bristle brush and spread out the bristles by applying pressure to a hard surface. Dab your brush into the highlight color and apply it creating clumps of leaves. Leave the dark background showing through to create depth within the leaves. Repeat this step to create brighter leaves if you want: Just be careful not to overwork this area of your painting.

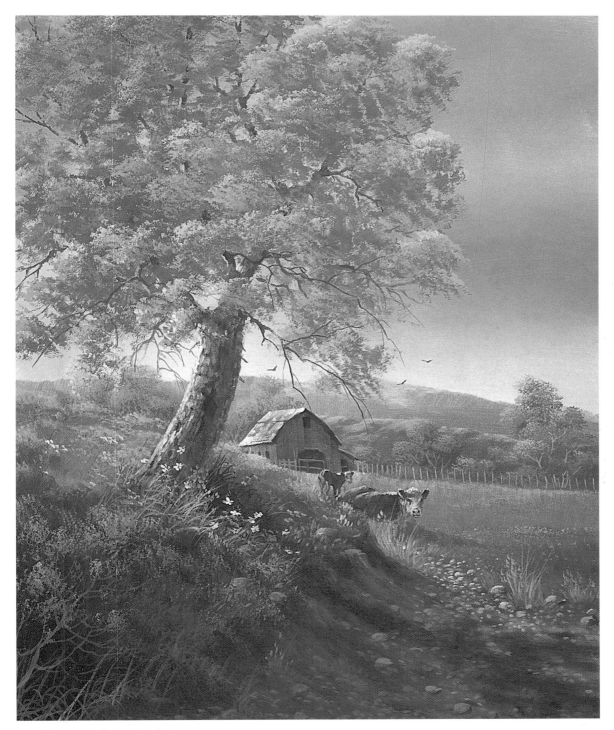

18 Complete Final Stage

The final stage for any painting is really exciting because this is where all of your efforts pay off. This painting does not require much finishing work: You may brighten a few highlights, add a few weeds or even dab on a few flowers. This part of the painting requires discipline in knowing when to quit. Be careful not to overwork, but enjoy adding some of your favorite touches.

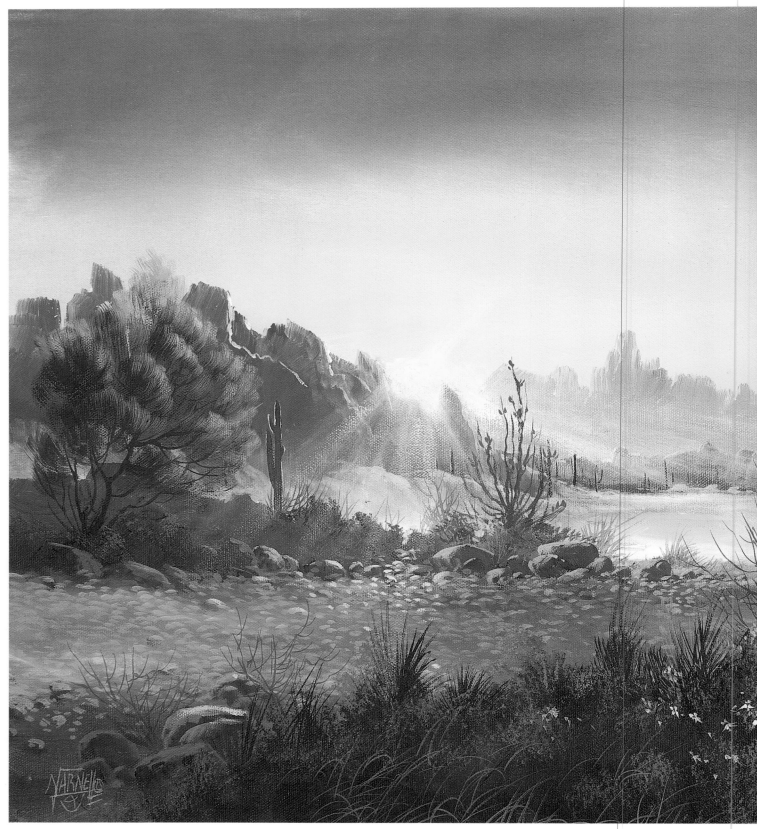

Desert Glory
16" x 20" (40.6cm x 50.8cm)

Desert Glory

I lived in the desert Southwest for many years and have developed a deep appreciation for this part of the country. I now know why so many artists settle in this region, because the reasons are the same as why I chose this as an instructional painting: light, subject and atmosphere. In this painting you will learn different blending and highlighting techniques, but most importantly you will learn how to create soft yet intense desert colors that transform a hostile and desolate place into a place of beauty.

1 Create Charcoal Sketch

Begin with a rough charcoal sketch of the main components of the composition.

2 Block In Horizon

Lightly wet the sky area with your haké brush and water. Apply a liberal coat of gesso. While the gesso is wet, apply pure yellow with your haké brush and blend it upward using large crisscross strokes. Use light strokes until the yellow disappears into the canvas.

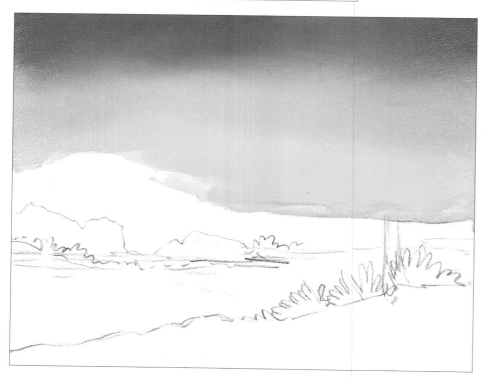

3 Block In Top of Sky

It is important that the sky remain wet at this stage. Use pure purple with your haké brush and begin at the top, applying a strip of purple across the canvas. Use large X strokes, blending the purple downward into the yellow. When the two colors meet, use a light feather stroke to blend them together.

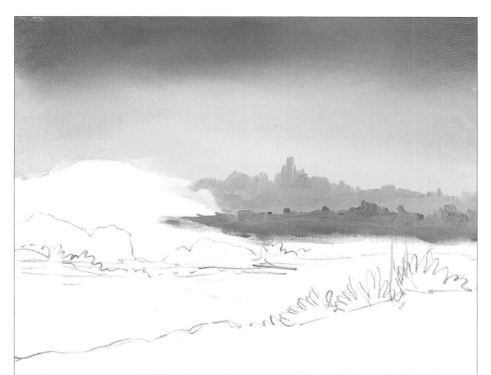

4 Underpaint Background Mountains

Mix white with a touch of purple, blue and Burnt Sienna: The color should be a soft purplish gray. Using a no. 6 bristle brush, block in some interesting desert shapes. Keep the edges of the mountains soft. You may add more purple to darken your mountain range or block in the next layer of mountains. Again, make interesting shapes and soft edges.

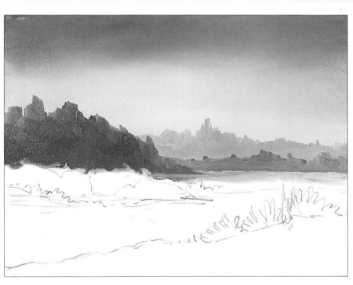

5 Block In Middle-Ground Mountain

Using the same mixture as in the previous step, add more purple and a touch of blue and Burnt Sienna to darken the value. Block in the middle-ground mountain with a no. 6 bristle brush. Notice the interesting pockets of negative space within the rock formations.

6 Underpaint Foreground Rock Formations

Mix white with small amounts of Burnt Sienna and yellow. Use a no. 6 bristle brush and apply color, using choppy horizontal strokes to underpaint the sunlit sandy area. Using the same dark mixture as in the previous step, add more purple and Burnt Sienna to darken the value. Block in the closer dark rock formations. Notice when you finish this layer that you now have four layers of depth of field: This creates great distance.

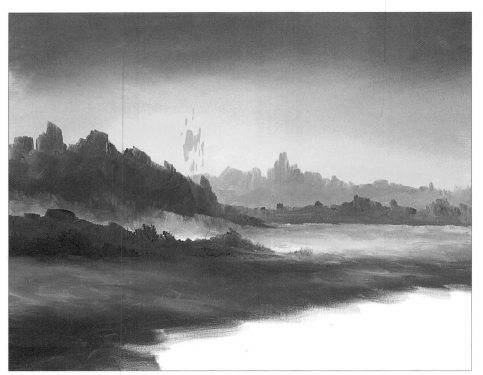

7 Underpaint Foreground Dirt and Sand

Do not premix this color on your palette: You will mix colors onto your canvas. Use a no. 6 bristle brush to apply yellow, orange, Burnt Sienna, purple and touches of white. Place these colors on the canvas haphazardly using horizontal choppy strokes. Be sure you have different pockets of light and dark contrasts. Do not overblend or it will mix into one solid color.

8 Underpaint Foreground Brush

This is a very simple step. Mix Hooker's Green, purple and Burnt Sienna. Using a no. 10 bristle brush, scumble the paint on thickly. Place your brush flat against the canvas and push upward on the wet paint creating a soft bushlike edge. Vary your shapes until they become interesting and appealing.

9 Detail and Highlight Distant Mountains

Mix a creamy mixture of white, yellow and a touch of orange. Choose either a no. 4 flat or no. 4 round sable brush and heavily load it with paint. Gently apply the highlight to the edges of the rock formations, similar to the silver lining applied to clouds. As you move forward from mountain range to mountain range, add touches of yellow or orange to intensify the highlights. Next, mix Hooker's Green, purple and a touch of white and use a no. 4 round sable brush to block in the distant bushes and cacti.

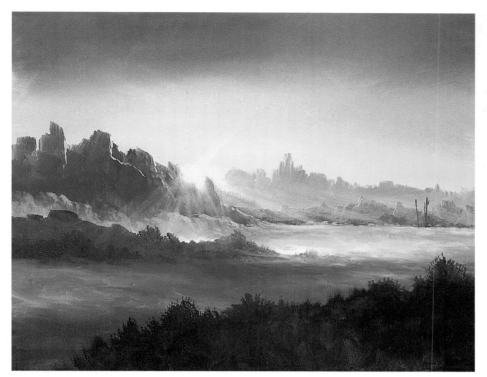

10 Block In Sun and Sun Rays

For this step, use a drybrush stroke and apply paint carefully. Mix white with a touch of yellow. Thoroughly clean your no. 6 bristle brush, then use it to dab a small amount of the paint mixture where the two mountains overlap each other. Take your brush and pull out from the sun barely skimming the surface of the canvas. This creates rays and a misty effect. Repeat this step as necessary to get the sun ray effect you desire.

11 Sketch the Main Subjects

The advantage of working with acrylic paint is that it dries so quickly. So you can use soft vine charcoal to sketch the main subjects on top of the underpainting. If you make a mistake, simply take a damp paper towel and wipe it away.

12 Underpaint Main Subjects

First underpaint the smaller rocks with a mixture of Burnt Sienna and touches of purple, blue and white. Use a no. 6 bristle brush and dab in the rock formations. Next add Hooker's Green to the mixture and block in the cactus with a no. 6 bristle brush, turning the brush vertically to the canvas. To block in the smoke tree to the left, use a no. 10 bristle brush. Roughen the end of the bristles so they become separated. Load a small amount of the same mixture and drybrush in the shape of the smoke tree. Use light feather strokes to give the tree a wispy, transparent look. Finally, thin the mixture with water and use a no. 4 script liner brush to put in the limbs at the base of the smoke tree and cactus.

13 Highlight Middle-Ground and Foreground Rocks

Mix white with a touch of yellow and orange to create a sunshine color. Using a no. 4 flat sable brush apply small amounts of the paint mixture by drybrushing the highlights on the top of each rock. Softly blend the sunshine color into the shadow side of the rock so it creates a three-dimensional form. Repeat this step where you want the rocks to appear brighter.

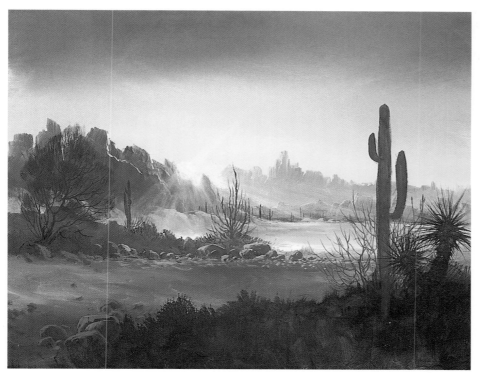

14 Block In Vegetation

You may add any type of desert vegetation you wish. However, the ocotillo plant in the middle ground and the yucca plant in the foreground are very artistic plants. To block these onto the canvas, use a mixture of Hooker's Green, purple and a touch of white. Use a no. 4 flat or no. 4 round sable brush. Make sure the mixture is creamy and give these plants good artistic form. Now block in any other bushes or cacti you wish—as long as you do not make the setting too busy.

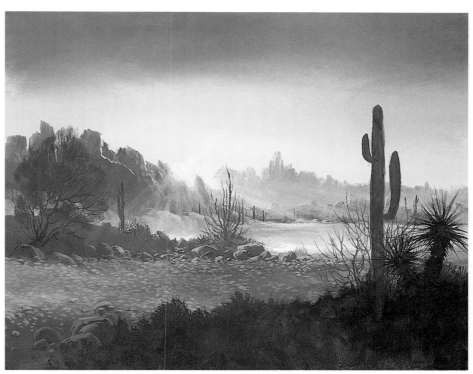

15 Highlight Pebbles

This is a fun step. Mix a creamy mixture of white with a touch of yellow and orange. Using a no. 4 flat sable brush, make small rounded humps overlapping and touching each other. Begin in the middle ground, working forward to create the suggestion of thousands of pebbles. This step can be time-consuming, so be patient—you will be rewarded.

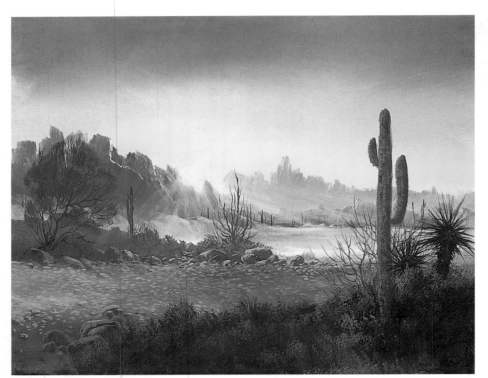

16 Highlight Vegetation and Underbrush

This step and the next step are very similar. First, mix white with a touch of yellow and Hooker's Green to create a soft greenish gray. Use a no. 6 bristle brush to drybrush a soft highlight onto the tops of the clumps of brush to create form. Then switch to a no. 4 flat or round sable brush and use short, choppy strokes to highlight the cacti and the yucca plant.

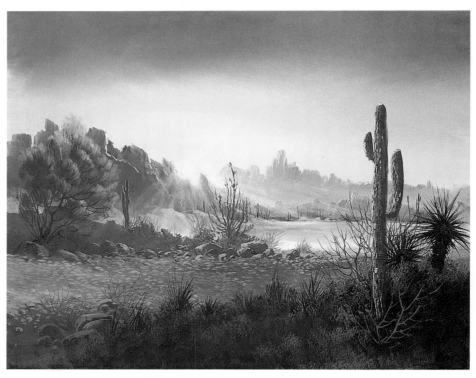

17 Continue Highlighting Vegetation

In this step we use brighter highlights and a little more color to make the vegetation stand out. Use pure red for the blooms on the ocotillo plant. Add a little more white to the greenish gray to accent the smoke tree and other bushes. Thin your accent colors with water to paint weeds, dead limbs, etc. Use a no. 4 script liner brush to create these accents.

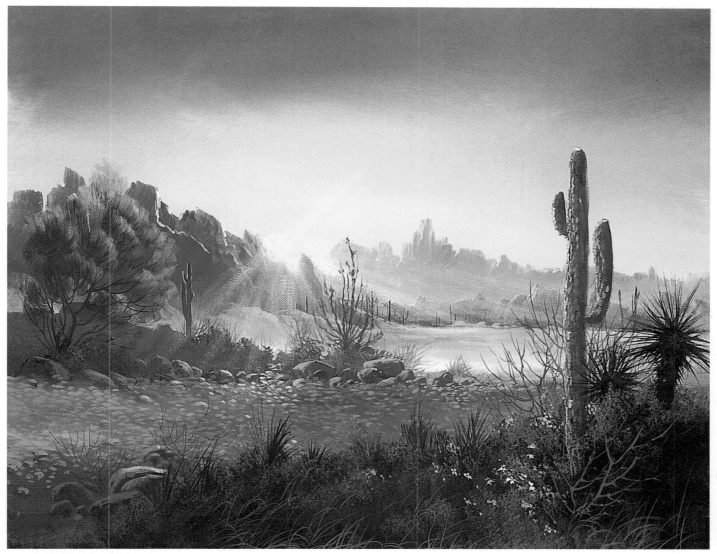

18 Add Final Details and Highlights

In this step add flowers and brighter highlights to some of the more important objects. When you mix a flower color, always add white to opaque the color. This will allow the color to be brighter and cleaner. It is a good idea to experiment with each of your brushes to see what kind of textures they create. Remember you only want to suggest flowers and final details: You are not trying to make it look like a photo. I hope you enjoyed painting this beautiful desert!

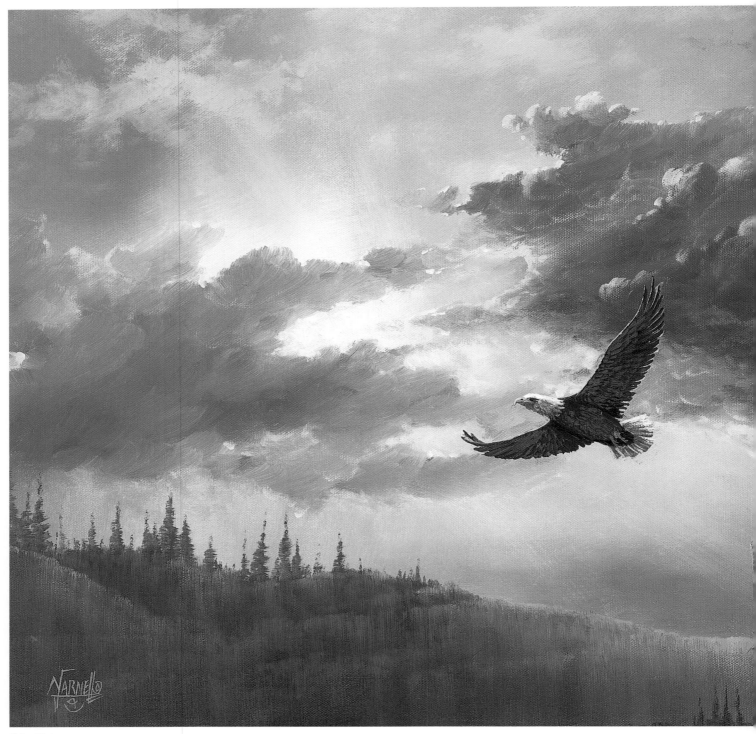

Flying High
16" x 20" (40.6cm. x 50.8cm)

Flying High

Two of my favorite subjects to paint are stormy skies and birds of prey. After teaching for twenty-five years, I have learned that skies always seem to be in the top five subjects artists want to learn—or are having trouble learning. Follow the instructions carefully for this dramatic painting, and I'm certain you will gain a much better understanding of how to create more exciting, professional looking skies that you can apply to your other landscapes. The eagle is a bonus to this painting and it is a great learning experience to paint.

1 Create Basic Sketch

Using your soft vine charcoal, make a rough sketch of the basic ground formations and locate the main cloud formations.

2 Underpaint Sky Background

First wet the sky with water using your haké brush. Then apply a liberal coat of gesso. Take a touch of Cadmium Red Light and a touch of purple and apply them at the horizon line while the gesso is still wet. Blend them upward with large crisscross strokes until you reach the sketch of the large clouds. Then on the upper half use blue with a touch of purple and a tiny bit of Burnt Sienna to gray the color. Blend this down to the cloud sketch, keeping the edges soft. Notice the light and dark patches.

3 Mix Paint

For this step you will need a no. 10 bristle brush and three different mixtures of paint: Ultramarine Blue, Dioxazine Purple and a touch of white; Ultramarine Blue, Dioxazine Purple and a touch of Burnt Sienna and white; and Ultramarine Blue, a touch of Burnt Sienna and white. Keep your mixtures on the purple side and mix them until they become creamy. Now take your no. 10 brush and begin scumbling on the first mixture, creating soft edges and nice pockets of negative space. Repeat the scumbling effect with the other mixtures. Apply these colors on top of the first mixture, creating different values, forms and depth. Scrub from one color into the next with the side of your brush.

4 Underpaint Foreground

This is a simple step. First mix Hooker's Green, purple and a touch of Burnt Sienna. Use a no. 10 bristle brush to apply a thick coat, using vertical strokes. Add touches of white as you go to create lighter values. It is perfectly acceptable for brushstrokes to show: This creates the texture for the underpainting of the trees. Be sure the canvas is well covered during this step.

5 Add Sun Rays and Highlights

In this step you will add the dramatic light behind the clouds. Mix white with a touch of yellow. Using a no. 10 bristle brush, dab this color in the light areas between the cloud formations. Application should be thick, and you should feather the paint out until it fades into the background. Allow this to dry, and then add another dab of this mixture in the center of the light area. While this area is wet, take your no. 10 brush and dry-brush from the center outward with long, straight strokes. Repeat this until the sunburst becomes very evident. You may also put a few miscellaneous highlights around the center of the clouds.

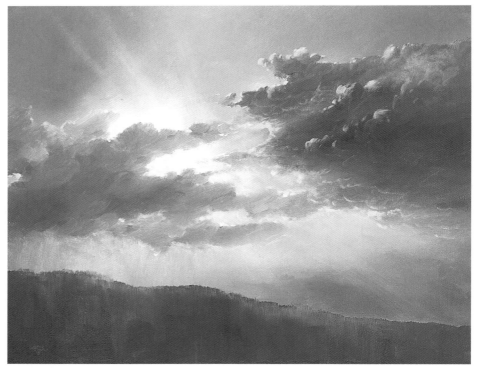

6 Add Silver Lining on Clouds

Use the same mixture as above, but switch to a no. 4 flat sable or a no. 4 round sable brush. Load your brush with the thick mixture and apply the silver lining around the edge of the clouds. Do not worry about blending during this step. You want the color to be sharp and clean. To create three-dimensional clouds, drybrush the highlights to create the forms you want, gently blending into the darker areas using your brush or even your finger.

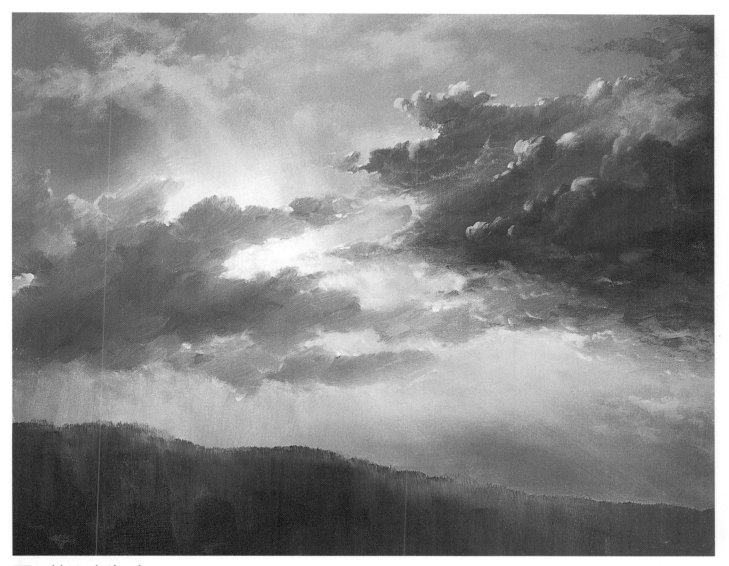

7 Add Final Clouds

Mix white with a touch of red and a tiny amount of yellow to create pink. With a no. 6 bristle brush, drybrush and scumble on the miscellaneous wispy clouds that you see above and below the main clouds. Take the purplish gray mixture from step 3 and scumble in additional darker clouds to finish out the composition. This is a great time to review your cloud formations. Make sure they all have soft, well-blended edges—except for those clouds with the silver lining.

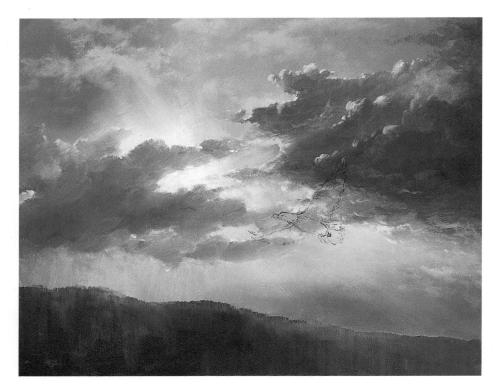

8 Sketch In Eagle

It is important during this step to have a very accurate sketch—even if you trace or enlarge your image with an opaque projector. Use soft vine charcoal, which is easily removed with a damp paper towel when you need to make changes in your sketch.

Close-up sketch of eagle

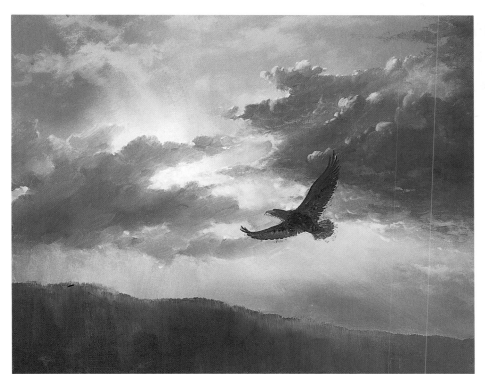

9 Underpaint Eagle

Use no. 4 flat and round sable brushes for this step. Mix Burnt Sienna, a touch of purple and blue to block in the main body and wings. Next, mix blue with a touch of Burnt Sienna and white to create a gray color. Underpaint the head and tail of the eagle with this color. Use orange with a touch of Burnt Sienna to block in the beak. After the paint dries, wipe off the excess charcoal with a damp paper towel. Now you are ready for the highlights.

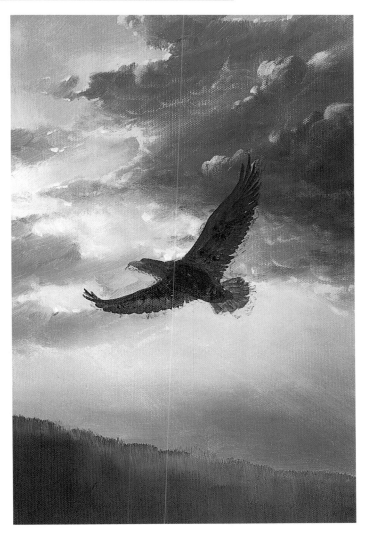

Close-up of under-painting

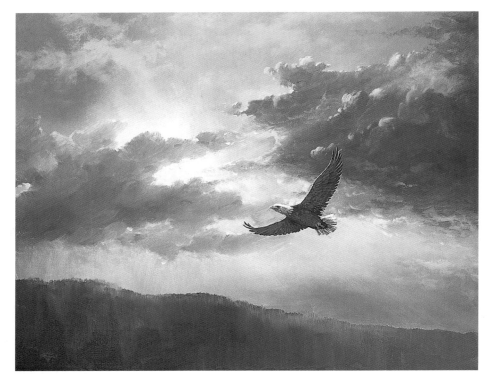

10 **Highlight and Detail Eagle**
First, take the dark underpainting color you used for the body of the eagle and add white to slightly lighten it, and add water to make it creamy. With a no. 4 flat sable brush, use quick, soft strokes following the contour of the bird. Begin with the long flight feathers, moving to the secondary feathers and finishing with the primary feathers closer to the body. Use short, choppy overlapping strokes for the body. Remember you only want to suggest detail. In flight it would be impossible to see much detail to the eagle's feathers. Highlight the head and tail with white and a touch of yellow. Make sure you leave some of the darker values showing through to create form. Use pure yellow to highlight the beak. Mix white with a touch of yellow and use your no. 4 round sable brush to place a highlight along the edge of the wings as you did with the silver lining on the clouds. Examine your eagle. If you have overhighlighted or overdetailed, you can correct it with a thin wash of the darker value to tone it down.

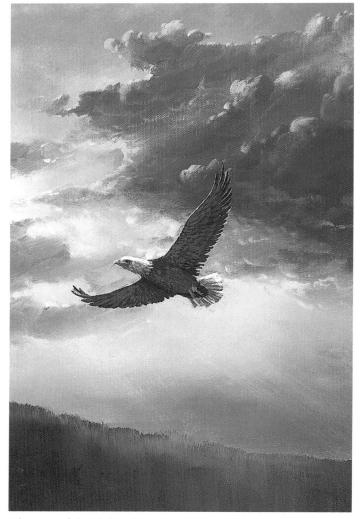

Close-up of detailed eagle

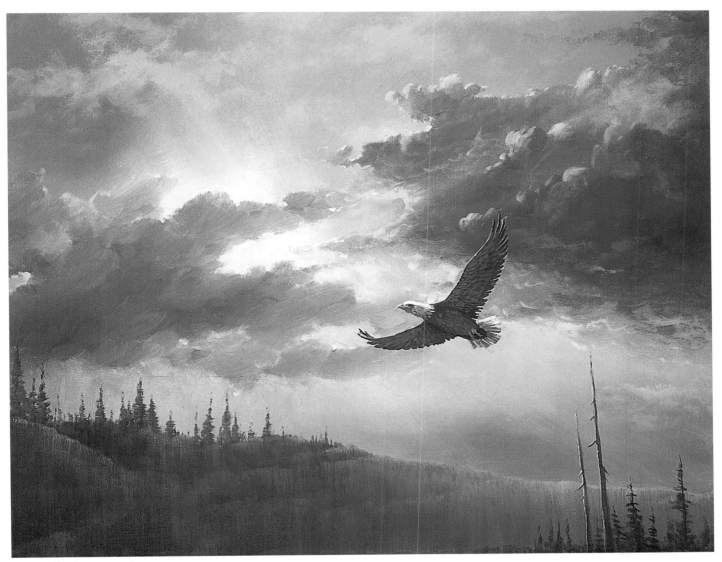

11 Add Foreground Details

By now you should be finished except for the foreground. At this step you will mix Hooker's Green and purple. Use a no. 6 bristle brush to dab in the silhouetted pine trees in the background. Add a small amount of white and yellow to the mixture and drybrush in some form highlights on the top of the hillside. Come forward, creating layers of depth. Now dab in the tips of some pine trees in the right-hand corner to act as an eye stopper. Scan the painting, make necessary changes—and you're finished.

Index

See How Wonderful Your Art Can Be with North Light Books!

Color Harmony
A step-by-step guide to choosing creative color combinations. The 1,662 combinations (grouped by hue, shade and purpose in combinations of two, three and four colors) will help you understand how colors work—and help you make choices with confidence. #07310/ $15.95/ 158 pages/ Color throughout

Splash 5: The Glory of Color
From the deep, moody blues of Bermuda to the simple poetry of a bright red watering pitcher, from delicate washes to thick, bold strokes, Splash 5 celebrates masterful and inventive uses of color. You'll see 125 paintings from 109 of today's finest watercolor artists. Along with the big, beautiful reproductions, you'll get insights from the artists on the colors they use—and how you can use them to bring emotion, sensation and energy to your work. #31184/ $31.99/ 144 pages/ 130 color illus.

Painting Fresh Florals in Watercolor
Learn Arleta Pech's simple secret for creating elegant, realistic watercolor florals. She'll show you how to layer different colors to create a wealth of rich hues. (She's included a handy color wheel of glazes for quick reference.) Next, step-by-step demonstrations show you how to use glazes to paint magnolias, dogwoods, daffodils, tulips, iris, roses, peonies, apple blossoms, leaves, lace and china. #31182/ $27.99/ 128 pages/ 220 color illus.

Trompe L'oeil
Find out how to use this fun, fool-the-eye style of painting to keep a vase of fresh tulips on your mantelpiece or transform a child's cupboard with images of bright toys. In step-by-step detail, you'll learn how to paint stonework, pediments and pillars; wisteria, ivy, miniature roses; floral wallpaper, swags and decorative trims; books, bottles, vases; and more. Eight projects demonstrate different ways of using trompe l'oeil on walls, cupboards and fireplace screens. #31130/ $27.99/ 144 pages/ 375 color illus.

The North Light Book of Acrylic Painting Techniques
No matter how you like to paint or how you like your finished piece to look ... acrylics can do it. And this book will show you how, through the diverse styles, work and advice of 23 acrylic master artists. See how Nina Favat applies her acrylics in loose, transparent washes. How William Hook achieves rich texture by working in thick, opaque strokes. And how Dean Mitchell uses watercolor to turn a hard-edged acrylic painting into an invitingly soft image. $23.99/ #31180/ 144 pages. 220+ color illus.

Painting Watercolor Portraits that Glow
A Jan Kunz's classic—now in paperback! Jan's expert instruction, along with her own glowing portraiture examples, make this book an all-time favorite among artists. Now it's back in a great, affordable paperback edition! Order yours and get Jan's secrets for painting accurate, lively, colorful portraits in eleven step-by-step demonstrations. $23.99/ #31336/ 160 pages/ 200 color/200 b&w illus.

How to Draw the Human Figure
Forget diagrams, cubes, ovals and matchstick men. This book is a guide to drawing the human figure naturally. Ambrus' masterful figure drawings were created from life, based on studio models. The drawings range from quick, one-minute sketches to completely finished studies produced with carbon pencil or charcoal. You'll get seasoned advice on such topics as foreshortening, shadows, rendering hands, creating a three-dimensional space, and how to avoid overworking. $24.99/ #31229/ 120 pages. b&w illus. throughout.

Painting the Drama of Wildlife Step by Step
Master wildlife artist Terry Isaac shows you how to turn nature's inspiration into unique and dramatic paintings. Working in acrylics, Terry shares his techniques for capturing the splendor of wildlife—from large panoramas to close-up views, from whales to cougars to hummingbirds. Filled with beautiful reproductions of Terry's outstanding paintings, this book offers a wealth of insight learned through years of experience. Four start-to-finish demonstrations show Terry at work. #31191/ $28.99/ 144 pages. 218 color illus.

Decorative Painting
Twenty projects show you how to inject life into ordinary furniture and accessories, with styles ranging from simple country to classic floral painting. Each project includes easy-to-follow instructions, step-by-step color photographs and a design template. This beautifully illustrated book opens with an illustrated, step-by-step guide to 17 basic decorative brushstrokes and tips on preparing surfaces. #31217/ $25.99/ 144 pages/ 125 color illus.

Painting Beautiful Watercolors from Photographs
Jan Kunz shows how to make great watercolor paintings inspired by photos. You'll learn how to take great reference photos; find many painting opportunities in one photo; combine two or more photographs convincingly; and 'solve' busy backgrounds, flat values, competing subjects and other common photo flaws. Eight complete painting demonstrations illustrate specific techniques for working with photos of flowers, children, animals and other subjects. Nine before-and-after demos show problem photos that intrigued Jan and how she turned them into successful paintings. #31100/ $27.99/ 128 pages/ 208 color/58 b&w illus.

Realistic Collage Step by Step
Collage is an exploration of image, texture and pattern—and a liberating creative experience for any artist. This book will teach you basic techniques for creating realistic images with cut papers, watercolors, acrylics, string, dried flowers ... anything that adds interesting shapes and textures. Step by step, you'll see how to assemble 12 different collages, from landscapes to still lifes. #31102/ $27.99/ 128 pages/ 145 color illus.

Artist's Photo Reference: Flowers
You'll find gorgeous photos of 49 flowers arranged alphabetically, from Amaryllis to Zinnia. Each flower is shown in a large primary photo, along with side views and close-ups of petals, leaves and other details. Many of the flowers are shown in various colors, too. Also included is brief information on scale, color variations and other facts to help you paint. Five step-by-step demonstrations in a variety of mediums show how you can use these reference photos to create beautiful floral paintings. You know the importance of strong reference materials. (And don't your paintings deserve the best?) With this unique book, you can use your precious time for painting, not research. #31122/ $28.99/ 144 pages/ 575 color photos.